Pelican Books
Image as Language

in the Channel Islands in 1939,
opher Finch studied at the Chelsea
ool. He is now on the staff of the
Art Center in Minneapolis. His
d criticism have appeared in
iterature, *Art International*,
tists, *Vogue* and *New Worlds*,
rrently writing another Pelican
rcadia, in collaboration with
He has acted as interviewer
on two films for the Arts
. Kitaj and Richard

CHRISTOPHER FINCH

Image as Language

ASPECTS OF BRITISH ART 1950–1968

PENGUIN BOOKS

Penguin Books Ltd, Harmondsworth, Middlesex, England
Penguin Books Inc., 7110 Ambassador Road, Baltimore,
Maryland 21207, U.S.A.
Penguin Books Australia Ltd, Ringwood, Victoria, Australia

First published 1969
Copyright © Christopher Finch, 1969

Made and printed in Great Britain by
Hazell Watson & Viney Ltd, Aylesbury, Bucks
Set in Monotype Scotch Roman

CONTENTS

ACKNOWLEDGEMENTS

Versions or parts of Chapters 1, 2, 4, 6, 8, 10, 12, 13, 15 and 18 first appeared in *Art International*.

Versions of Chapters 3, 14, 16 and 17 first appeared in *Art and Artists*.

Parts of Chapters 1, 2, 8 and 13 first appeared in *New Worlds*.

Thanks are due to the editors of these magazines for permission to reprint this material.

INTRODUCTION

During the latter half of the 1950s the visual arts seemed to be suddenly, and rather unexpectedly, the centre of great general interest and controversy. Almost overnight artists became subject to the kind of treatment that has been reserved, at other times, for personalities in the entertainment and fashion industries. This tendency began in New York, possibly with the first impact of Jasper Johns and Robert Rauschenberg, and it soon spread to the remainder of our Western version of the civilized world. In Britain, as in America, the phenomenon has been especially pronounced. Painters such as Peter Blake and David Hockney have been accorded the status of folk heroes.

This shift in public interest coincided with the artists' renewed concern with the everyday world – and especially with such pop-oriented zones as packaging and advertising art. The public could find in this something with which to identify. The cult of personality tended to interfere, however, with any direct approach to the work and so the emphasis was all too often shifted to the artist himself. Painters and sculptors were photographed for the Sunday supplements and the glossy monthlies; their work might appear too – if it provided a suitable background. Hockney's

bleached hair and gold lamé jacket provided both copy and visuals, and a good deal was made of Peter Blake's levi suit covered with badges.

On the credit side, this growing interest may have boosted the confidence of the artists but the haze of publicity tended to conceal the fact that associated with these names were potentially important formal and imaginative statements. The purpose of this book is to explore the aims and achievements of some of the most important figures associated with this period of British art.

This book does not attempt to define a consciously integrated art movement. It does, however, discuss a number of artists whose work is related to certain central themes and who, taken as a body, represent what I believe to be the most significant phase, to date, of British art in the twentieth century. The character of the phenomenon with which I am dealing is complex and can only emerge through an understanding of the artists concerned. I shall however attempt to sketch a brief outline of the thematic background which has governed my choice of artists.

The distinguishing characteristic of the art discussed in this volume is the use of imagery as language. All painting and sculpture can, of course, be discussed as the manipulation of visual language; but in recent British art this manipulation of language has taken on a special significance. Most of the art discussed here must be 'read' – it relies as much upon an informed scanning of the way different idioms are meshed together as upon direct

retinal response. This is not as forbidding as it may sound since often the idioms concerned are the common currency of advertising art translated into a fine art context. In an art of this kind the artist relies upon shared experience. The viewer is invited to enter the composition rather as though it were a poem addressed to a friend.

The dangers inherent in this kind of art should be admitted from the first. A skilful manipulation of language is not an automatic guarantee of the physical impact that we can expect from great painting. On the contrary an over-emphasis on the manipulation of language may well block this kind of impact and the attempt to encompass too wide a linguistic range has been one of the great weaknesses of recent British art. The manipulation of language for its own sake is none the less an exciting and potentially constructive concept; a concept that, properly controlled, can lead to a very high level of art. One purpose of these essays is to unearth, where possible, actual and prospective control factors. Two or three of the artists discussed here have already imposed stringent controls upon their working methods (or, perhaps more accurately, have recognized control factors that were implicit within these methods). They have defined for themselves areas of language – comparatively narrow areas, perhaps – which have become second nature and can serve as a basis for an original exploration of pure plastic relationships. The character of these relationships is defined by the linguistic structure of the painting and thus takes on the appearance of inevitability which is one of the marks of major art.

These potentials of image as language are discussed in some detail in the main body of the book. First we might

consider the question 'Why has this kind of art evolved in Britain at this time?'

My answer is perhaps over-simple but I believe it to be an approximation of the truth. Painting is, at its best, a very natural activity and reflects the character of the painter. The character of the painter is influenced by his cultural environment and this is in turn affected by the spoken language. English is a compound tongue evolved from many different sources. This may help to explain the richness of English literature but in the visual arts – where range of allusion is not as vital as density of expression – it has not always been an advantage.

With very few exceptions English artists were out of tune with the artistic revolutions that swept the rest of Europe during the early decades of the twentieth century. To slice across the traditional dogmas of art, painters were forced to adopt clear-cut positions and to employ single-minded methods – logical, once given propositions were accepted. The texture of the English language and of British cultural life was not well suited to activity of this sort. A British painter who tried to put himself in time with the polemics – either verbal or visual – of, say, purist abstraction, was apt to find himself at odds with his own natural inclinations.

By the 1950s, however, modern art appeared to have exhausted its initial fund of dogmas – either that, or the artists had simply grown tired of them. Young painters were able to look back over half a century of modernism and did not limit their interest to any one movement or tendency; they found things to admire and be interested by in all aspects of the new painting and were able to

accept without difficulty work produced from many different polemical viewpoints which had at one time seemed mutually contradictory, mutually destructive. These young painters began to construct for themselves a new language – creating a synthesis from the dozens of different idioms which had evolved during the crusading period of modernism (their heroes, figures like Duchamp and Picabia, who had always ignored the hard and fast divisions between one school and another). In this new language many viewpoints are given an equal footing; ambiguity has become the *status quo*. Just as English is a compound from many different sources, so the vocabulary of modern art now draws upon the vocabulary and syntax of many different idioms. The English-speaking artist is at home in this medium. It is perhaps no accident that the ball has bounced into the Anglo-Saxon court.

The breakthrough came in America, where connexions with the École de Paris had never been as institutionalized as in Britain. Also – if paradoxically – the wartime presence of European artists and intellectuals in New York gave American painters a sense of urgency which, until recently, the British have lacked.

The Americans took the new vocabulary and added another dimension – much as Shakespeare and his contemporaries took the format of the Italian drama and translated it from a purely Mediterranean experience into a more general – Atlantic – experience. English painters retain, for the most part, a European sense of scale and structure and use the new vocabulary as poets have always used the English language. Prolonged contact with American art may modify this (as it has done already).

Along with the linguistic synthesis came a new interest in subject matter. It is sometimes suggested that the 'New Realism' was simply a reaction against the years of abstraction – a return to the image for its own sake. To an extent this is true, but beyond this there was also the feeling that most modern painters – however revolutionary their method of organizing pigment on canvas – had failed to come to terms with the changing facts of the outside world.

The mushroom growth of the media of mass communication had completely transformed the visual world and presented situations quite outside the scope of primitive modernism. To turn to the imagery projected by mass media was, for many young artists, simply to return to their native landscape. They were at ease with that world and it was natural for them to introduce it into their work. The necessity of translating mass media idioms into fine art terms again placed an emphasis upon the conscious manipulation of image as language.

Inevitably the critics spoke of Pop Art but – even if we admit that it existed as a distinct phenomenon – it must be emphasized that this was a movement differing in character from all previous movements (different even from Dada if we exclude one or two practitioners) in that it did not preach an *exclusive* method of treatment or investigation. Rather it opened its windows on the world at large and accepted everything that presented itself; it was an art of *inclusion*.

Pop Art was only a temporary focus in a much wider evolution towards enlarging the artistic experience into a new and broader lyricism. Many artists once labelled Pop have already moved on to new fields but, at the same time,

the impetus given to them by acceptance of ad-mass
techniques and imagery remains an historical fact – a fact
which there is no going back on.

Some major British artists – Anthony Caro and John
Hoyland for example – clearly fall outside the scope of this
survey. Their work belongs to another tradition. Other
artists have presented a greater problem. I was tempted to
include a chapter on Derek Boshier, who was at one time
identified with the Royal College group which included
Hockney, Jones and Phillips. It seems to me, however,
that he can be fairly judged only in terms of his more
recent work, which does not relate directly to the central
concerns of this book. Mark Lancaster's subtle canvases
have an allusive quality which relates him to several artists
discussed here. At the same time I am unable to escape the
conclusion that to adopt the bias which would integrate
him with my theme could only distort the real nature of his
work. It may be thought that two or three of the artists
I have chosen are marginal figures. This is possibly true,
but in each case I have felt that there has been either a
substantial contribution to the character of the evolving
scene or else an exploration of technical matters that helps
us to understand the more central figures.

I have included two American artists (Kitaj and
Haworth) who have been resident in London for a number
of years and can most profitably be discussed within the
context of recent British art. I have included one British
artist (Laing) who is resident in New York. Richard Smith
has divided his time between London and New York since
the late fifties. Phillips, Jones, Hockney, Tilson and

Paolozzi have had periods of residence in the United States, and all but one of the artists to whom I have devoted chapters have visited the United States on at least one occasion. Most have also exhibited there.

The transatlantic interchange implied by this has been a key factor in the evolution of recent British art.

PART ONE

1 · Richard Hamilton

b. 1922

Richard Hamilton's work is in some ways difficult to come to grips with. He has had exhibitions and participated in many group shows but, until recently, has seemed to function less as an artist in his own right than as an undercover agent for various new tendencies in the art world. The diversity of his activities has given his career an enigmatic quality, and – like all enigmas – it has invited speculative penetrations. Often people have been content to describe Hamilton as a key figure in the rise of Pop Art; yet there is clearly quite another dimension to his work.

The most dangerous frame of reference that offers itself is his association with Marcel Duchamp. Hamilton's link with Duchamp began with his preparation of a typographic version of *The Green Box*, which was published in 1960; it culminated in the reconstruction, for the 1966 Tate exhibition, of *The Large Glass*. That Hamilton feels a great sympathy for Duchamp's work is self-evident, and regular contact with a mind of the calibre of Duchamp's cannot have been without effect. At the same time Hamilton's art follows a perfectly logical trajectory from the work that he was doing when Duchamp was no more than a name to him. Many concrete similarities arise from an intrinsic similarity of creative temperament. It becomes

important to look at the differences between the two men
and the most basic is probably that, while anxious, like
Duchamp, to put painting back into the service of the
mind, Hamilton has no phobia regarding retinal painting.
On the contrary, an investigation of methods of retinal
communication has been one of his main concerns.

It is easy to have the impression that Duchamp is a
thinker who (briefly) painted. Hamilton is essentially a
painter who thinks.

In the paintings that he did in the early fifties – immedia-
tely after leaving the Slade School – we find him pre-
occupied with perspective in a very original way. A
painting of this period is built up of small marks, each of
which has its function in a given system of perspective.
There may be several vanishing points and centres of
vision so that as the painting is built up, certain marks
may come to function in more than one system. This
approach to perspective has more to do with analysis than
with any kind of *trompe l'œil* effect and – like a Cézanne
landscape – is 'complete' at any stage. That is to say that
the success of the painting relies upon its own internal
tensions, which are established from the outset, rather than
upon the completion of any illusion.

Across some of these early canvases, organic shapes are
strung. Another shows a speeding car and analyses the
apparent pivoting motion of the background. These in-
trusions of the physical world relate to two didactic
exhibitions (didactic as opposed to fine art in that they
dealt with specific themes in terms of photography,
montage, etc.) which Hamilton devised in the first half of
the fifties.

The first of these exhibitions, 'Growth and Form', took place at the Institute of Contemporary Arts in 1951 and was concerned with organic growth; with the world of the microscope and the telescope. The second, 'Man, Machine and Motion', was staged in 1955, firstly in Newcastle (where Hamilton had become a lecturer in the fine art department of the University) then moved to London – to the I.C.A. once again. As the title indicated, it was complementary to the 'Growth and Form' exhibition, concerning itself with the man-made world – and especially the iconography of transport – from the primitive bicycle to space travel.

The I.C.A., it will be seen, provided a centre for these activities and, within the I.C.A. itself, a focal point for new ideas was provided by the Independent Group which included among its members, Hamilton, Eduardo Paolozzi, the architects James Stirling and Peter and Alison Smithson, as well as the critics Reyner Banham and Lawrence Alloway.

From the beginning the Independent Group was interested in the subject of popular culture. At its first meeting, in 1952, Paolozzi used an epidiascope to project a series of pop images taken from the world of ad-mass and science fiction. Later a convener was elected to organize the group's activities. Reyner Banham was the first and he called in guest lecturers to talk on subjects ranging from logical positivism (A. J. Ayer) to helicopter engineering. Banham was succeeded by Alloway and the emphasis shifted. While from the point of view of painting Alloway was chiefly preoccupied with Abstract Expressionism, his extra-mural interest in popular culture led him to turn the

group's activities firmly in that direction. Marshall McLuhan was kicked into the vanguard (*The Mechanical Bride* had recently appeared) and Alloway proposed a theory of a fine/pop art continuum. Reformulating this theory, in 1961, for the magazine *Image*, he dismissed Roger Fry's 'disinterested aesthetic faculty, uninvolved with the rest of life'; instead he suggested 'a descriptive aesthetic which acts not as an ideal but as a commentary on one's experience in the world'.

As no acknowledged experts could be found to lecture on popular culture the members of the group were themselves pushed into this role. Banham gave a talk on car styling and Hamilton himself lectured on consumer goods (it should be stressed that the emphasis was still on 'popular art' as opposed to Pop Art in the sense that we now understand it; the continuum had been proposed but was not yet in operation). Hollywood movies were discussed in sympathetic terms and Alloway brought an interest in some of the newer scientific disciplines – cybernetics for example – which were beginning to filter through to the general public. In retrospect Hamilton thinks that very few members of the Independent Group went very deeply into any of these subjects at this stage. At the same time they were made aware of vast fields of visually and intellectually exciting material beyond the vacuum of the English art world.

The first public manifestation of these new ideas came at the Whitechapel Gallery, in 1956, with the exhibition 'This is Tomorrow'. The exhibition consisted of a dozen stands on each of which a different team of architect/painter/sculptor had collaborated. A glance at the cata-

logue tells us that, in numerical terms, the show was dominated by the English constructivists; but the two displays which created the greatest interest were those that were activated by the spirit of the Independent Group. Paolozzi had joined with Nigel Henderson and the Smithsons in designing an absolutely basic living unit (catering for all man's essential needs down to 'artifacts and pin-ups – for his irrational urges'). Hamilton, in collaboration with John McHale and John Voelker, created an environment which has been called 'the first genuine work of Pop'; it combined a large-scale use of popular imagery with an imaginative exploitation of perception techniques. Prominent were a sixteen-foot robot – with flashing eyes and teeth – making off with an unconscious starlet; a blow-up of Marilyn Monroe; a gigantic Guiness bottle. These large items were at the rear of the exhibit; small objects were placed at the front so that a reverse perspective was created.

The soft floor, which was a feature of this part of the environment, was graded from white to black so that a supplementary illusion was produced. Elsewhere the floor of a corridor was graded in strips to create an impression of undulation – an impression which was amplified by optically disturbing patterns painted on the walls. Another section of floor – part of a science-fiction capsule – was painted with fluorescent red paint, covered with expanded metal and flooded with black light. In a tall chamber some of Duchamp's rotor reliefs spun in a setting which was itself an optical illusion. Smells drifted about the whole exhibit; several movies were projected at the same time while a juke-box played in front of a huge collage

of film posters which curved round like a cinerama screen.

The concept of all this was almost exclusively Hamilton's: John McHale had been in the United States during the greater part of the planning period.

The best known single item from 'This is Tomorrow' is the collage that Hamilton made for the catalogue: *Just what is it that makes today's homes so different, so appealing?* It incorporates much of the Pop subject matter that has become so familiar – comic-strips, television, pin-ups, automobile imagery, the cinema. In his statement for the catalogue Hamilton wrote:

We resist the kind of activity which is primarily concerned with the creation of style. We reject the notion that 'tomorrow' can be expressed through the presentation of rigid formal concepts. Tomorrow can only extend the range of the present body of visual experience. What is needed is not a definition of meaningful imagery but the development of our perceptive potentialities to accept and utilize the continual enrichment of visual material.

This is a key statement. 'The present body of visual experience' incorporates both fine art and popular imagery. There is also an implied necessity for perception research and it is the coming together of these elements that marks Hamilton's later work. He has not found it necessary to choose 'Op', 'Pop', or 'painterly', yet the interests of each of these three choices are reflected in his art. When we turn to the paintings which Hamilton began to work on at about this time we begin to see why it is that his art is so difficult to come to grips with. Many artists seem to spring into the international arena with a ready-

formed style (and all too often continue to fake their own work indefinitely). Hamilton by contrast, has examined each of his different starting points in some detail and has synthesized them only very gradually into a personal idiom – an idiom that he subjects to constant re-programming so that it is never in danger of atrophy.

For most of 1957 (interest in his work was not, at this time, overwhelming and he was not forced into over-production) he worked on a group of studies and drawings which culminated in the painting *Hommage à Chrysler Corp* (Figure 1). In the spirit of Alloway's fine/pop art continuum, he embarked upon an investigation of American automobile styling – as expressed through the filter of magazine advertising – without in any way relinquishing the position of the fine artist. 'The main motif, the vehicle,' as Hamilton describes it,

breaks down into anthology of presentation techniques. One passage, for example, runs from a prim emulation of in-focus photographed gloss to out-of-focus gloss to an artist's representation of chrome to ad-man's sign meaning 'chrome'. Pieces are taken from Chrysler's Plymouth and Imperial Ads, there is some General Motors material and a bit of Pontiac. The total effect of Bug Eyed Monster was encouraged in a patronizing sort of way.

There was also a sex symbol, 'engaged in a display of affection for the vehicle'. She is elliptically represented by the Exquisite Form bra diagram and Voluptua's lips. Hamilton was inclined to suppress a similarity to the Winged Victory of Samothrace, worried by the accidental reference to Marinetti's dictum – 'A racing car . . . is more beautiful than the Winged Victory of Samothrace.' Finally,

the setting of the group is 'a kind of showroom in the International Style represented by a token suggestion of Mondrian and Saarinen.'

Hommage à Chrysler Corp was followed by another exploration of the conjunction of sex, architecture and car styling – *Hers is a lush situation.* A styling analysis of the '57 Buick, which appeared in *Industrial Design,* had concluded with the following words: 'The driver sits at the dead calm centre of all this motion: hers is a lush situation.' Hamilton set about reconstructing the motion about this dead calm centre with the same precision that he had once applied to the problems of perspective. Above exotic curves of pressed steel, his Sophia (the lips this time were Miss Loren's) slips past a fragment of the U.N. building.

In *She*, Hamilton transferred the sex symbol to the kitchen. Vikky (the back) Dougan is evoked by the curve of her hip and shoulder, a single kinetic eye and an ambiguous cleavage. A vast refrigerator yawns behind her; a toaster, which is at the same time a vacuum-cleaner, confronts her. The language invented for the presentation of consumer goods is investigated in the terms of fine art. As in the early perspective studies the painting is superficially incomplete in that it does not attempt to sustain an illusion, but the disparate elements are held together by tensions within the painting. Now, however, each element is a symbol and their sum conjures up a whole world of consumer/ad-mass imagery. Hamilton talks of 'a sieved reflection of the ad-man's paraphrase of the consumer's dream'.

Where does he stand with regard to all this? Lawrence Alloway has remarked

Hamilton's position is that of a knowing consumer, a role typical of other English painters, abstract and figurative. This is a drastic departure from both the bohemian tradition of distrusting possessions (being a bad consumer) and from the high spiritual aims declared by early modern artists.

It may be argued that the knowing consumer is not so much abandoning spiritual aims as adopting new ones. I have observed elsewhere that there exists 'a taoism of the object, a notion of idyllic (or at least ironic) determinism' which has a considerable appeal to a number of contemporary artists. Accepting his position in a deterministic chain (Rauschenberg talks of the artist becoming aware that 'he is part of an uncensored continuum that neither begins with or ends with any decision or action of his'), the painter accepts the objects that constitute his environment in a new way. John Cage accepts chance noises in the street as music. He is at the same time concerned with the idea that the purpose of music is 'to sober and quiet the mind thus rendering it susceptible to divine influence' and he equates 'divine influence' with the Zen ideal of 'waking up to the very life we are living'.

In these terms, then, a key aspect of the Spiritual is the phenomenon of feed-back from an acceptance of the life we are leading to an awakening to that same life.

There were some, however, who distrusted Hamilton's intentions. A cultural attaché at the American Embassy in London expressed concern that such paintings as *She* and *Hommage à Chrysler Corp* were satirical attacks on the American way of life. Hamilton was so amused by this misreading of his aims that he decided (by way of a gesture) to explore the language of satire. As his subject

matter he selected Hugh Gaitskell, who had come near to
breaking the left wing of the Labour Party by declaring
his intention to preserve Britain's nuclear role should the
party come to power. A newspaper photograph of Gaitskell
began to converge upon a magazine cover showing Claud
Rains in his make-up for *The Phantom of the Opera*. The
result was *Portrait of Hugh Gaitskell as a Famous Monster
of Filmland*. As always with Hamilton's work, the fact
that he is exploring a language does not imply that the
end product exists exclusively in that language. Always
there is the translation into the language of fine art. Thus
the *Portrait* is not so much a satirical painting as a painting
of a *possible* satirical painting.

Each of Hamilton's paintings (along with its accom-
panying series of studies and drawings) is the solution to a
given problem – an analysis of a visual language (or a
cluster of languages; the mixing of idioms is often an
essential feature). While slowly evolving his own idiom he
has been content to explore other people's dialects with a
detachment that is at once scientific and aesthetically
descriptive in the sense meant by Alloway. (Hamilton
admires a group of films – amongst them *Prince Valiant,
Beyond the River, Garden of Evil* – made by Henry Hatha-
way in the mid fifties. Each of these films explores a
specific area of language in much the way that Hamilton
does in his own paintings.)

In *Pin-Up* he explored the language of the girlie picture
with something of the detachment that a sociologist might
adopt to conduct a survey of the working habits of
Japanese strippers (we must assume that this hypothetical
sociologist would not think that a sense of irony interfered

with objectivity; we may speculate further that the objectivity of many experiments is marred through lack of irony). In *Pin-Up* there are all the iconographic elements that one would expect; the swollen breasts – the fetishism of bra, pants, stockings, spike-heeled shoes. We see also a record player that is at the same time a telephone – a cipher for an environment, loaded with implications. Hamilton has noticed that, in order to heighten the skin tones, the entire picture will have been flooded with these same tints (this is especially the case with the more expensive *Playboy* type of image-making); thus the painting is saturated in flesh colour. By way of a fine art reference, one passage hints at Renoir's brushwork.

Another and more complex exploration of language is represented by the series *Towards a definitive statement on the coming trends in mens-wear and accessories.* Of the main paintings in this group, one – *Together let us explore the stars* – concerns itself with man in a technological environment; another with 'the sporting ambiance' and a third – *Adonis in Y-fronts* – 'attempted to catch some timeless aspect of male beauty. Certain contours were derived from the Hermes of Praxiteles – other parts were from muscleman pulps.' A fourth painting (a null-gravity picture in that it can be hung in any orientation) synthesized various elements from the other three.

The *Interior* series of 1964 was triggered off by a publicity still from the forties film *Shockproof* which Hamilton had chanced upon – an abandoned remnant of some class exercise – in a Newcastle studio. It showed the actress Patricia Knight standing, somewhat uneasily, near a large desk in a severely opulent Hollywood interior. The

atmosphere of the photograph was so strange that it was some time before Hamilton noticed a body lying on the floor, half hidden. Intrigued, he set about an analysis of the still.

Everything in the photograph converged on a girl in a 'new look' coat who stared out slightly to right of camera. A very wide angle lens must have been used because the perspective seemed distorted, but the disquiet of the scene was due to two other factors. It was a film set, not a real room, so wall surfaces were not explicitly conjoined; and the lighting came from several different sources. Since the scale of the room had not become unreasonably enlarged, as one might expect from the use of a wide angle lens, it could be assumed that false perspective had been introduced to counteract its effect yet the foreground remained emphatically close and the recession extreme. All this contributed more to the foreboding atmosphere than the casually observed body lying on the floor partially concealed by the desk.

In a series of collages he set about reconstructing 'this image of an interior space – ominous, provocative, ambiguous; with the lingering residues of a decorative style that any inhabited space collects. A confrontation with which the spectator is familiar yet not at ease.'

In these collages he also explored such incidental interests of his as the image within the image. In one interior, an exterior event – a football match – is taking place on a television screen (and the television set itself is montaged on to a canvas standing on an easel). We may recall that in *Just what is it that makes today's homes so different, so appealing* we discover, on the television screen, a woman talking into a telephone. If we remember that

this collage was itself intended for reproduction by offset litho we find that we are confronted with a potentially infinite media chain.

In the *Interior* series, the next task was to reconstruct the desk which is a key feature of the original photograph. Instead of taking the perspective of the original as his model, Hamilton recreated the desk upon a printed perspective grid such as architects and technical draughtsmen employ. By adopting this method, which is from a technical point of view very practical but aesthetically arbitrary, by ignoring the usual conceptual machinery of the artist, he introduces an element which authentically simulates certain aspects of the cinematic image – the studio necessities of distorting lens and false perspective.

In the first of two final versions this desk and the silk-screened image of Patricia Knight were brought together – along with other elements both painted and collaged – into a large-scale translated reconstruction of the original visual experience. This painting was marked by a strong period feeling and he went on to do a second version (see Figure 2), attempting to sustain the disturbing atmosphere while transferring the actress to more contemporary surroundings. The desk was removed and a feature was made of an elegant metal chair. Perspective effects are engineered with tasteful woodwork and parquet flooring. The ornate wall decorations have vanished and instead – on a projecting panel that might be read as a canvas – is a television set. On the screen, generally unnoticed by the casual observer and ignored by the figure in the painting, we are shown the assassination of President Kennedy. The idea of death (echoing the body hidden by the desk) is reintroduced

along with the notion that the greatest event of the
century could be going on 'in the room' without our
noticing it.

The exploration in series of ideas (or languages) is
Hamilton's habitual method of working but there have
been exceptions. His first visit to the United States (at the
time of the Pasadena Duchamp exhibition in 1963)
prompted two isolated works. *Epiphany* (Stephen Dedalus
used the word to describe anything of outstanding personal
significance) is a large disc inscribed with the words SLIP
IT TO ME. The colours have been so chosen that, in certain
lights, the letters appear to flutter.

Hamilton writes of *Epiphany*:

The button which is its source was bought in a seedy joke shop
in Pacific Ocean Park. On my return it stood for much of what
I had enjoyed in experiencing the States but it also summed up
that which I most admired in American art, its audacity and
wit.

Turning to the other post-American work, he continues:

A little bit of Roy Lichtenstein for . . . (made at the same time) is
just that – an enlarged detail of a weeping girl's head. It seemed
only reasonable to take the serial process to its logical con-
clusion and make an art work from a piece of a Lichtenstein art
work from a piece of comic strip.

Hamilton also hoped to demonstrate that Lichtenstein's
work depended not, as some critics were suggesting, on the
elegance of his calligraphy but upon the precise masking
of the image – upon finding exactly the right relationship
between the image and the edge of the canvas. In enlarging

one small detail, all of Lichtenstein's superficial elegance
was lost; yet Hamilton was able to retain the essential
Lichtenstein quality.

Recently Hamilton has been engaged upon two groups
of works, each of which has in some way gone further than
anything that he has previously attempted. The first goes
beyond the exploration of a specific idiom to an investiga-
tion of some of the most basic facts regarding language and
communication.

He was intrigued by the discovery (in a magazine article)
that Marilyn Monroe, in vetting her publicity photographs,
had savagely defaced any that did not please her. The
fascination of the hand-made marks disfiguring the
mechanically made image of their author prompted
Hamilton to assemble a number of these mutilated photo-
graphs into a composition (Figure 3). This in turn prompted
him to embark upon other paintings in which the relation-
ship between the freehand graphic statement (the calli-
graphic mark) and the mechanical image (the photograph)
was explored.

On a landscape – an aerial view of the South Downs –
marks that seem to have strayed from gestural abstraction
are superimposed; also fragments of green sponge that
might be read as trees. A still life photograph, showing
part of a table roaster and a pair of champagne glasses,
has been carefully sprayed with photo-tint colours. Here
the artist has been able to function without modifying the
intrinsic quality of the photograph. The photograph itself
was chosen for a particular reason. The table roaster
shown is an extremely elegant sample of consumer goods.
The main stream of Pop Art had emphasized the vulgar

aspect of popular imagery. Hamilton did not want it to be forgotten that there was another side to the question.

In other pictures of this group a further idea is introduced. Hamilton has been struck by the fact that in photographs of crowd scenes virtually amorphous blobs can easily be read as human beings. He experimented with enlarging distant sections of beach and city scenes to see if these qualities of readability were retained. To a large extent they were. Taking these enlargements as a starting point he overlayed them discreetly with paintmarks. A new ambiguity was introduced but they remained readable (Figure 4).

Hamilton has often used low relief, to emphasize the curve of flesh or a lacquered tail-fin, but in one recent group of works he has ventured into three dimensions in a more substantial way. His subject matter here is, in the simplest sense, the Solomon R. Guggenheim Museum (a complement, perhaps, for Lichtenstein's temples). In a more complex sense it is the language of architecture, of architectural renderings – a study of how we see architecture (Figures 5 and 6).

Six large fibreglass facsimiles of the Guggenheim, moulded in deep relief, form the material basis of the group. Each is treated in a different way. On one, for example, cleanly painted black 'shadows' are the only additions to the stark white relief; we are reminded of the architectural photographer's taste for bright sunlight. Another relief is overlayed with metalflake so that the linguistic tensions are set up between the quality of the surface and the precisely realized concrete form.

What makes Hamilton's work so interesting is, ulti-

mately, the quality of his thought, but the quality of his thought is intrinsically linked – even when he is dealing with architecture – to his interest in media of communication. In a modern society where everyone is engaged in a constant confrontation with all kinds of often highly sophisticated visual communication, it is perhaps inevitable that the thinking painter should become engaged in this way. In Hamilton's work the medium is the message – but not in quite the sense proposed by Professor McLuhan.

'Fine art', says Hamilton, 'is the medium in which I work; the mass media is often the content of the painting.'

The medium is the message; but the message is transmitted through another medium – one which affords us the leisure to discover just what that message is.

2 · Eduardo Paolozzi

b. 1924

*'It's easy enough to find the right answers to the right problems.
What interests me is to find the right answers to the wrong
problems.'*

In 1952, as mentioned in the last chapter, Eduardo
Paolozzi projected, for the pleasure of members of the
I.C.A.'s Independent Group, a programme of imagery
taken from the budding worlds of ad-mass and the new
technology. Advertising material, SF illustrations and
electronics diagrams – seen in an unfamiliar context and
on a greatly enlarged scale – suggested areas of visual
delight unsuspected at that time by most of the audience.
In Paolozzi's sculpture of that period this visual delight
remains latent; it is subordinated to the physical properties
of the medium and to the search for the non-art object.
For almost another decade this remained largely the case.

But in his newer work this visual delight has become
articulate – placing the physical properties of the medium
at a different remove. In consequence his sculpture has
been totally transformed and he has branched out into
other fields – graphics, the cinema, the confrontation of
word and image. A new relationship to the world is sug-
gested and a new relationship is implied between Paolozzi

and his work. The sculptures have become extremely beautiful – even glamorous – but now he is somehow detached from them. Unlike the traditional fine art object they lack the delusory significance of Unique Importance (as do the graphics, the books, the films). They are the results of chosen activities but they do not aspire to be anything more than part of the world.

For Paolozzi sculpture *in itself* is of no special interest. 'Whatever I'm doing at the moment is the important thing.'

To discuss sequence in relation to his recent output is of only moderate interest. His different activities are in no way dependent upon one another but all spring from a single awareness and from a single metaphysical curiosity.

In the 1950s Paolozzi was a leading exponent of the anti-art ethic. In his work he constantly posed the questions, 'Am I an artist? Is art possible?'

Paolozzi's newer work offers an answer to these questions – identical in both cases: 'Yes, but that doesn't really matter.'

The insight that permits him to say this equally allows him to solve other problems. Why debate the position of the artist in a sophisticated technological society? He is in one. . . . He needs only to admit the fact to see the problem drop from sight. Accept the environment and a new crop of benefits offer themselves. In Paolozzi's view anyone today can become a poet, a musician, a sculptor. You have only to open your mind and to liberate the faculty of choice. Other people have the practical skills.

Paolozzi remarks that nobody would expect an aero-

dynamicist to build his own wind tunnel and as John Cage
has written:

The use of technological means requires the close anonymous
collaboration of a number of workers. We are on the point of
being in a cultural situation, without having made any special
effort to get into one (if one can discount lamentation)....
The heights that are now reached by single individuals at
special moments may soon be densely populated.

There is no point, however, in *competing* with technology.
Accept its methods – and its economics if necessary – but
compete and everything is lost (although the anonymous
beauty of technology offers a model for art).

Within the context of the electronic age – employing
its methods and imagery – Paolozzi engineers magical
objects.

'You can', he observes, 'shut yourself away in some
artists' colony – St Ives, say, or Paris – with a sack of
plaster or a box of oil paints. The life still has its appeal
and maybe one in 100,000 – I don't know the mathematics
of it – will do something. But it will be a freak – the out-
come of something totally subjective.'

Klee introduced into art the information of biology,
ethnology; now they are part of the total vocabulary.
There is no turning back. Duchamp introduced everyday
objects and the determinism of love. This is a *fait accompli*
and to reject it is arbitrary. In the present the vocabulary
of art expands towards the inclusion of everything. Every-
thing seen in a certain way becomes art. (And what if, in
the process, art as such becomes irrelevant?)

It may still be possible to achieve something within the

traditional brackets of art (gestural abstraction as much as court portraiture falling within these brackets); but why restrict yourself when the odds can be lengthened to infinity?

CHRONOLOGY

In the late fifties Paolozzi was casting in bronze sculptures which were still in a brutalist idiom but whose surfaces were formed through the impression of machine parts.

In 1960/2 he was visiting professor at Hamburg Hochschule. He would take a group of students selected from various faculties – arts and science – on expeditions to shipyards, steel mills, etc. (These expeditions sometimes extended over several days.) Discussion would follow. During this period he began to make – in plywood – engineering templates. A few of these were translated into metal.

Back in England he went on to have cast – from standard engineering templates and machine parts – his series of *Towers* (*Wittgenstein at Casino, The World Divides into Facts* (Figure 7), 1963). These are monolithic pieces reminiscent, as has been remarked elsewhere, of slot machines, fairground machinery and IBM equipment. They recall also certain aspects of German Expressionism – *Metropolis* and the whole atmosphere of the machine ethic. At first they were cast in gun metal. Soon Paolozzi found aluminium more convenient and satisfactory.

Having established contacts with a producer of precision industrial castings in Fulham and an engineering works in

Ipswich, he next produced pieces welded together from standard machine castings (*Crash, Artificial Sun, Lotus Parrot*, 1963/4). Extending this technique he has created highly polished pieces from castings of his own design (*Akapotik Rose, Rizla, Marok-Marok-Miosa*, 1965). Later he extended this series further using new sections and selecting a painted finish in place of the polished surface (*Esse-Ess, Lilacapnoea, Pisthetairos in Ipsi* (Figure 8), 1965).

As a contrast in method ('I took advantage of the fact that a truck from the chromer called at the works twice a week') he has also produced a group of elegant plated corrugations (*Foto, Jasmin, Twisprac, Durenmal* (Figure 9), 1965).

Paolozzi quotes with enthusiasm an ambition of Victor Mature's. Mature employs a double whenever possible and hopes one day to be the star of a movie in which he does not actually appear.

At the works (art is produced here along with crane bearings and aircraft components) Paolozzi gives instructions as to how the castings are to be assembled. Since this is a non-union firm the same man is able to assist him at all stages – welding, bolting, and even painting the finished piece.

While Paolozzi is quite able to lend a hand, and is not superstitiously set against doing so, he prefers to leave the body of the work to the professional. He is himself the contractor and his function is to take the decisions. One of the chromes takes about a month to complete but it requires his physical presence for less than a day.

In the creation of his magic objects he continues towards the anonymity of pure technology. In common with other artists of his generation he has moved progressively further and further from the concept of art as signature. (It has been said of Marcel Duchamp that he gambled for the prize of anonymity and lost. Paolozzi has lost too and continues to double his stakes.)

That Paolozzi continues to have direct contact at all with his work is partly a result of the complexity of his interests. Despite the apparent simplicity of some of his pieces he is the opposite of a reductionist. He is not concerned with creating a *Gestalt* object which simply *is*. Each of his works is a linguistic prism: a pencil of language strikes it and a spectrum of vocabulary and syntax is transmitted.

Paolozzi has a prodigious appetite for language and for communication. The Science Museum, the Natural History Museum, the Library of the American Embassy – the contents of these institutions have been annexed by his imagination. The Leicester Square–Charing Cross Road area – the bookshops by day and the cinemas by night – is for Paolozzi a constantly shifting encyclopedic experience. A pulp magazine may provide the starting point for a sculpture. An Audrey Hepburn movie becomes at once a declaration of love and a source of information (the demarcation zone between love and information is abolished). A Chicken Inn or an automatic vendor can take on the same aspect; can become the entrance to another universe. America is a vast projection of all this.

The European's dream of America (like the American's dream of Europe) is a fluid medium of love/information

that can never be wholly explored. The imagination both travels through this medium and feeds off it (like an airliner sucking in air in order to burn the oxygen). Paolozzi is a kind of latter-day Doughty, exploring the post-McLuhan dream version of the New World. Doughty went to Arabia to save English prose from the slough into which it had fallen. Perhaps Paolozzi has some similar aim in mind. But, although a pioneering explorer of the dream, Paolozzi is sufficiently sensitive to America to remain in touch with the American reality. This contact with the reality is vital if the dream is to have any value. Jim Dine has said that Paolozzi and Richard Hamilton are the only British artists who are able to make him look at the United States in a new way.

For Paolozzi, England is a good place to work but he talks of visiting New York or California 'to recharge'.

In scrap books reminders are stored: micro-electronic circuits/car stylings/Japanese neon/building blocks/s f fantasies/mathematical models/colour printing oddities/ architectural schema/weaving patterns/Micky Mouse and the historical cartoon galaxy/a model named Paolozzi (in more than mascara)/metal extrusions/3 D molecular diagrams/space hardware/fuel pipes etc.

Much of this material is classified according to Paolozzi's own system. There is for instance a silver scrap book covering anything from chrome bumpers to silver clothes. Another is called *Dance*. This consists largely of Fasching costumes clipped from German glossies (extraordinary photos of a girl in black stockings, with black lipstick). These are the raw materials of Paolozzi's language

games – mechanically produced images of the world that surrounds us.

When I talk about language (words, sentences, etc.) I must speak the language of every day. Is this language somehow too coarse and material for what we want to say? *Then how is another one to be constructed?* – And how strange that we should be able to do anything at all with the one we have. Wittgenstein, *Philosophical Investigations*.

It should not be surprising to find the name of Ludwig Wittgenstein cropping up in relation to Paolozzi's work. He accepts language games at face value; creates new games from fragments of existing languages; contributes fragments to new languages.

That he does not find it necessary to invest his language games with some supposed meaning beyond themselves is a mark of spiritual poise. The refusal to assign this supposed meaning is – paradoxically – what gives them meaning; is what translates these games into magical objects. ('The World is all that is the case.' Wittgenstein, *Tractatus Logico-Philosophicus*.)

Wittgenstein's life too is of significance to Paolozzi. The position of the foreign intellectual in Britain is one that has an obvious relevance for him, and Wittgenstein's idealism – as well as his thought – relates to Paolozzi's imagination.

The series of screen prints *As is When* (Figure 10) – published in 1965 – is based on the life and writings of Wittgenstein.

Collages were prepared from a kit of weaving diagrams, engineering patterns, etc. Screens were made from these by Christopher Prater. The twelve resulting prints reflect

events in Wittgenstein's life or ideas from his writings (Paolozzi is moved equally by Wittgenstein's visits to the cinema and by his thoughts on reality and experience).

In structural method the series is a projection of Wittgenstein's thought. ('A *picture* held us captive. And we could not get outside it for it lay in our language and language seemed to repeat it to us inexorably.' Wittgenstein, *Philosophical Investigations*.)

from Wild Track for Ludwig
The Kakafon Kakkonn laka oon Elektrik Lafs:

In the diagram a forest scene is being changed into a cottage interior the bottom of the scene that moves across the stage has a few domes of silence hammered in. The sun sank with its burning arrows. The soldiers marched, bowed and grim. The air boiled thickly and threatened to choke them. The hills on the left held their breath. A solitary cloud on the horizon. Dull clothes being blown about. The actress leaning forward as though struggling against the wind, as she walks away from the manipulator of the threads. A scene of inevitable destruction. The younger son, helpless, his legs bound, his body crumpling, lapses into unconsciousness and death, fatally wounded. The band played while members of the engineering department brought out ropes and pullies, cables and derricks, beams. The general public knows little of him. But he has a softer side. He has written a poem, its last lines run 'did you hear what the bird said?' 'I did' said Algebra 'it is made in small pieces.' That a man has been taught the ordinary use of the words 'the same' in the cases of 'the same shape', 'the same length' give point to this argument, the Grand Master then conducted his audience to another part of the forest. Can the

dancer learn a regular labyrinth path more quickly than an irregular one? Now to the left, now to the right running in circles, passing through it would eliminate the extraordinary cleavage of directions. Pictorial figures may be substituted for circles. Safeguarding the operation of these elevators free flowing scrawl work designs of a floral character. Stage effects sound of heavy beams falling, which sound may be got by a muffled big drum or a heavy piece of wood, as a post is held vertically and brought down with a thud upon the stage. The band, palm up in a gesture of eloquent of horror and futility like the forearm was bent backwards and down, in the direction of various sound effects required from time to time, as birds singing, a policeman's or railway guard's whistle, ducks quacking a fog horn for a ship at sea and other semi-musical instruments, all of which suffer from no lack of systematic books.

<div align="right">Paolozzi, 1965</div>

CHRONOLOGY

Since the fifties Paolozzi has experimented with the programmed or random reorganization of words, using a collage method reminiscent of Burroughs, Gysin, Dieter Rot.

In the early sixties he produced *Metafisikal Translations* – a book in which words and images are freed from the normal restrictions of sequence and syntax (sequence and syntax still exist here but are constantly shifting; the reader is free to scan the material in any way he likes).

In 1967, he 'wrote' a collage novel, KEX, published by the Copley foundation. In this case Paolozzi has simply selected the material and handed it to the editor (Richard Hamilton) to organize as he thinks best.

But his most ambitious venture into the field of para-literature is the box, *Moonstrips Empire News* (Figure 11).

Material from the scrap books – text and image – is montaged on to large sheets of card (by Christopher Prater mostly: Paolozzi functions once more as contractor). An IBM typewriter has been employed in the preparation of the text. Images are organized sometimes by class – visual or linguistic; often by a process random or simply convenient. In any case they *appear* to be organized; the spectator's eye accepts the fact of organization even as it performs the task of reorganization.

From these montages screens were made and from these screens the proofs were taken. Some are printed on trans-parent paper so that, for instance, a complex of images may be seen through a sheet of text. The images are not necessarily screened to correspond to their original colour format; there are translations and inversions. The sheets are loose in their container, in no specific order. The owner of the Box, then, becomes his own editor. Once more Paolozzi's physical contact with the work is minimal. The Box is, however, entirely the result of an elaborate choice pattern on his part.

Comparison with Duchamp's *Green Box* is inevitable. Paolozzi says of this that perhaps no one has ever read it entirely; that it is the isolated thoughts contained in the *Green Box* and, above all, the concept of the entire project

that made it what it is. Duchamp's attitude of combined attachment and detachment transformed the *Green Box* into a magical object.

The ready mades too were magical objects and in *Moonstrips* and the projected sequel *General Dynamic FUN* (Figure 12) the lessons of ready made and *Green Box* are combined. It is in fact a box full of ready mades. If Paolozzi has been able to ignore, without risk of devaluation, Duchamp's suggestion 'Limit the no. of rdymades yearly (?)' this is perhaps due to a change in climate. Or is the Box after all a single combine ready made?

Paolozzi's Box is a prism diffracting the language and information of an era. Another parallel suggests itself: *Finnegans Wake*.

If *Moonstrips* is retrospective, in content, then the emphasis of *Universal Electronic Vacuum* (1967) (Figure 13) shifts towards the potentials of the present and the future. Certainly Jayne Mansfield and Paolozzi's favourite Disney characters feature here – but with a special function and retaining few traces of pure nostalgia. The predominant note – taken up at once by the IBM-style lettering of the poster – is the computer age; but this is not simply the usual naïve flirtation with electronics which we have become so familiar with in the arts lately. Paolozzi said of *Moonstrips* that it was largely concerned with the relationship between kitsch and technology. The same might be said of *Universal Electronic Vacuum*. What interests Paolozzi is (a) the way in which technology is harnessed to satisfy popular taste, and (b) how it influences popular taste. This kind of relationship can be traced back at least

as far as the iron Chippendale furniture of the 1851 Great
Exhibition. Today it can be seen in the toy department of
Woolworth's, in the design of automobiles or television
sets. It is strongly rumoured that the hardware of the
American's Apollo space programme has not been con-
ceived without a glance at the popular idea of what a
space craft should look like according to the canons of
pulp science fiction (and, after all, Werner Von Braun has
himself written sci-fi).

In *Universal Electronic Vacuum* the print *Memory
Matrix* appears to be a representation of just that – an
elaborate configuration of printed circuits. The caption
text – taken from a scientific dictionary – amplifies this
expression. The image is, in fact, adapted from the design
of a cheap, plastic tablecloth. In fine art terms one can
relate this to the cubists' habit of including scraps of news-
paper and fabric in their paintings; or one could talk of
Duchamp's ready mades. All that is relevant but equally
important in this instance is the complex relationship
which Paolozzi perceives between taste and technology.
The original tablecloth was, after all, a mechanical repro-
duction of woven pattern which retains some significance
for suburban housewives (just as the stones of the Parthe-
non retained the imagery of timber architecture). What
Paolozzi has done is to take this transliterated imagery
and return it symbolically to a technological setting – with
the same gesture advancing it in time and setting up an
elaborate pattern of cross references.

Mickey and Minnie Mouse are also here represented as
they might be reconstructed by a computer. Decorative
packing papers are turned to new and unexpected uses,

as are the miniaturized LP sleeves that – arranged in neat
rows – advertise cut price record clubs in glossy magazines
(these in fact supply the title of one print: *Whipped Cream,
A Taste of Honey, Peanuts, Lemon-Tree, Others*).

In *Universal Electronic Vacuum* the computer world is
reproduced in terms of metaphor. The time may soon be
with us when artists like Paolozzi actually employ com-
puters to programme their work, but here the principles
of the method are simulated. The print is programmed in
so far as it is carried out by craft specialists according to
specifications supplied by the artist. The data to be pro-
cessed is pasted up, by the artist, into a montage and the
processing is then carried out according to his instructions
– but not by him. This second stage of programming is
verbal and relies upon empathy between the artist and the
technician – a system which has both advantages and
disadvantages when compared with the mechanical effi-
ciency of a punched card. In human terms a concrete
metaphor is achieved for computer methods. The metaphor
is sustained by the imagery. Photographic images of actual
computer circuits are used in some prints but beyond this,
throughout the suite, images deriving from quite different
(though possibly related) sources are translated into that
same visual idiom. Some of these have already been noted
but we may add colour charts, children's games, flow
diagrams and strips cut from Mondrian's *Broadway Boogie
Woogie*. Each of these may have – perhaps has inevitably –
further significance for the artist but the key factor here
is that Paolozzi achieves a dynamic relationship between
method and imagery. He does not make the mistake of
flirting with techniques that are for the moment beyond

I.L. – 3

the scope of the artist, where the attempt can only seem mawkish. Rather he pushes those techniques which are available to their logical extreme, creating a rich nexus of ideas which matches – conceptually – the complexity and sophistication of the world with which he is dealing.

Of course it is quite possible to enjoy these prints in purely plastic terms. The bands of colour which disintegrate the two-dimensional surface of *Horizon of Expectations* represent a plastic device which other artists might have lived off for a couple of decades. The richness of formal invention matches the conceptual richness of the prints (and is, it may be supposed, directly related to it). This two-fold richness, combined with a sure grasp of matter and method, is what remains most impressive about Paolozzi's work.

The cinema offers another form of diffraction grating. In 1962 Paolozzi made a film – *The History of Nothing*.

Notes on the Film *The History of Nothing*

The history of painting. The history of the object. The history of man can be written with objects. All sculpture is a man-made object. Machine as fetish Cylinder block Trojans column Laocoon As votive the crankshaft erotic Segments of information Enlarged mechanisms positioned carefully in a tiled interior.

Floral motive embroidered punched out of metal Architectural decoration enigmatic expression in a semi-circle of dots

A church tower overlaid with a generation symbol. A church entrance draped with lace. A mask

The interior cut away showing a lovely lady in tights with a floral cluster attached to her crotch

This dissolves into a series of flower motifs Translations if you like Hand embroidered and hand drawn.

Beyond form Within the meaning the structure of references, allusions

Layers of paradox

Recognition of man-made objects Musical references, etc.

Rejection a tool as important as say acceptance A continual diary of opposites Nature as fabricator, man as engineer

The leaf and wheel The tree and the engine Layers of cultural auro divisions of time revalued

Continual movement positioned carefully Degrees of ambiguity suppressed Some kind of technical involvement The dropping or placing of elements Carefully fabricated precisely made into a larger complex A new union interlocked conglomeration.

The History of Nothing: *a continuation of the script:*
Space monkey Grinning Pathos Distorted lunatic cat Whiff of anti-war Bottom of rocket Hybrid mutant boiler head attached to winged clowns mask Hybrid in interior

Close up Readymade Technics room altered Hard diagonals Convex hexagons Series of punched squares Slots containing circles Triangular edges to horizon tall and vertical Loco wheel altered Jewellry on a wrist with watches Square clock face Clock of straw Expose gear box

<div align="right">Paolozzi, 1962</div>

Movies, sculptors, books are integral to Paolozzi's life; they are an essential part of the mechanism but at the same time they are not given some special status apart from

life. A corollary to the notion that anyone, open to certain
insights, can become an artist is that an artist, open to
these same insights, can become anyone.

To accept the mystery of the world as it is has been the
insight that has sparked artists since the cooling of the
Romantic era. Nerval was able to accept his own incipient
madness and use it as a pinnacle from which to snatch a
glimpse of this objectivity; but how many other minds
prior to the last decade, were able to achieve – even briefly
– anything like this order of spiritual clarity? Rimbaud
(what else did he mean by rediscovering the spirit of the
Greeks?), Lautréamont (who in the *Poésies* became the
theorist of clarity), Jarry, Duchamp, Picabia . . . it might
be possible to augment the list to a couple of dozen names.

Now the climate has changed and is still changing.
Excuses melt but Paolozzi has joined those who no longer
need them.

3 · Richard Smith

b. 1931

When Louis Daguerre employed his primitive camera to register stains on a copper plate, in more or less recognizable configurations, pessimists forecast the death of painting. The rise of the cinema provoked a renewal of these warnings but all that happened in both cases was that painters underwent a change in sensibility as a consequence of these new visual experiences. That the Impressionists were influenced in their methods and approach by photography is well known, and the cinema had a stimulating effect upon many of the early modernists.

It is with similar but more recent shifts in sensibility that Dick Smith has been concerned – shifts engendered by, for example, the introduction of technicolor and cinemascope, new techniques in packaging and presentation, changes of style in advertising photography. He argues it has become impossible to see – for instance – a beach in the Bahamas, except through the filters, accommodating lenses and slurring shutters of the brochure photographer – further transformed by the necessary simplifications of cheap colour printing. He has not been alone in making these observations but he differs from most of his contemporaries in that, whereas they address themselves to the end product – the recreated image –

he concerns himself primarily with the actual change in sensibility.

A contemporary of Peter Blake's at the Royal College, Smith was contributing articles on popular culture to *Ark* as long ago as 1956. His interest in this field was amplified by the chance discovery of Marshall McLuhan's book *The Mechanical Bride* which deals very graphically with new media of communication and this may have helped to deflect his attention from the actual imagery of Pop to the means by which it is transmitted to the public. He seems to have realized at a very early stage that the mechanics of stereoscopic vision, say, or the games that commercial photographers play with the concept of focus (how much has our mental life been altered by daily contact with those words 'out of focus'?) were well worth investigating in their own right.

At about the same time that he first encountered McLuhan's ideas he also came across, in Paris ironically enough, the paintings of Sam Francis. These were, Smith says, the first paintings that he had seen which went beyond the 'traditional' modernism of the École de Paris and they impressed him greatly. He began to paint in a style based on Abstract Expressionism – exploring soon the possibilities of the 'all-over' painting as practised by Jackson Pollock – but, from the first, his concern with the various media of popular communication found a place in his work if only in that it liberated him from prevailing plastic conventions.

In 1959 Smith moved to New York on a Harkness Fellowship and, during his initial stay of two years, definite forms began to make their appearance in his paintings.

At first this was chiefly a stylistic change – defined areas
of colour gradually replacing the all-over brushwork of
Abstract Expressionism – but by the time of his first
exhibition, at the Green Gallery in 1961, he was making
quite specific references to billboard advertising and slick
photographic techniques. Having come to satisfactory
terms with the language of the new painting, he was mov-
ing on to make a systematic investigation of the visual
mechanics of the Soft Sell (Figure 14).

In the earlier Abstract Expressionist work, reference to
popular culture had been on a very general level – a paint-
ing might recognizably share a sense of scale, an area of
retinal sensation, with a wide screen commercial, but little
more. Now, while his canvases remained painterly enough
to satisfy even 'pure painting' fetishists, Smith's concern
with the technical aspects of mass media – with the mani-
pulation of vision – became far more graphic. Once the
viewer had come to terms with the idiom (and, as the
paintings were of considerable interest in themselves, this
was not an unrewarding task) he was able to grasp the
machinery of communication almost physically.

In 1962 his interest in packaging led him to paint the
first of the canvases by which he is perhaps best known –
the 'box' paintings. Boxes suggestive of cereal or, most
frequently, cigarette packages were presented in dramatic
perspective. Although recognizable they were never by any
means *trompe l'oeil* representations (if an actual brand
name did make an appearance in one painting it was in
answer to an attack on Pop Art made by Peter Selz in a
lecture at the I.C.A.).

Often the image was multiple, imitating the repeat

motifs of commercial art; and other ad-mass devices –
spotlighting for example – were explored.

Generally these paintings were large, sharing a sense of
scale with cinema and billboard advertising where, as the
artist has observed, 'you could drown in a glass of beer
and live in a semi-detached cigarette packet.' Also he
began to employ the shaped canvas, in order to accom-
modate his boxes more effectively. This was followed by
the use of three-dimensional extensions to the painting,
once more paralleling the practice of the billboard artist
who will frequently build out from the picture plane in an
effort to give the advertised product an extra dimension
of 'reality'.

In the 1963 painting *Vista*, boxes painted in rough
perspective are superimposed upon one another – the
largest, partially occluded box forming an extension on
two sides of the normal rectangular canvas. Other ideas
besides packaging are present; the title also hints at the
movies (the Vistavision symbol telescoping towards the
audience – and the boxes could equally be read as the wide
screen and tiered auditorium of a modern cinema). But
even within the context of the 1960s the word 'vista' is not
without overtones of landscape – or at least cityscape –
some kind of panoramic view. The inventors of Vistavision
certainly kept this in mind when they christened their
brainchild; promises of visual exhilaration are sown in the
minds of prospective audiences.

It is just this exhilaration that Smith translates into
terms of painting. *Vista* embraces the cinema, the ad-mass
presentation of packaging and the concept of landscape,
but strips all these of their usual superstructure of imagery

so that we are left with the *impact* of the advertisement –
minus the commercial message – and, without topography,
the sheer sensation of wide open spaces.

Similarly *Fleetwood* (Figure 15), a conjunction of iso-
metric boxes, combines the packaging motif with the
advertising convention of presenting motor-cars in floating
perspective. Reduced to a common denominator of form,
the American car is not far removed from the cigarette
packet in its overall shape, and methods of presentation
are closely related. It is these similarities of presentation
that interest Smith (Figure 16).

Driving along highways the senses are tempted by
monotony and repetition into abandoning their usual
mechanics of discrimination and coming to accept roadside
advertisements as natural phenomena. The hoardings
become virtually a part of the landscape and, like these
hoardings, a vast painting such as *Gift Wrap* (1963)
(Figure 18), with its enormous three-dimensional extensions
seems to exist in a no-man's-land between the manu-
factured image and the world at large. Even the colours (a
mixture of the natural and the man-made) and their
application (in part loose, in part controlled) hint at this.
Gift Wrap remains essentially *a painting* in that its three-
dimensional elements are related to the picture plane
rather than to space in any abstract sense, as would be
the case with a free-standing object; at the same time it
does have this quality of seeming to invade 'the real
world'.

As much as anybody, then, Smith is capable of answer-
ing Rauschenberg's call to artists to fill the gap between
art and life, but he differs from almost all other pop-

oriented painters – both English and American – in one important respect. I have said that whereas they are preoccupied with imagery he is concerned with sensibility. This implies a technical difference which must have a considerable influence upon the long-term development of his career.

The standard tool of the orthodox pop painter is collage. I do not mean that they all literally paste magazine pictures on to their canvases but they are concerned with organizing ready-made images taken from the consumer/ ad-mass world and collage is the basic technique behind any manipulation of ready-made imagery. Even an artist like James Rosenquist is creating what can be thought of as handpainted collages – adapting to a transatlantic vocubulary and syntax a method that Magritte employed for forty years. In general, it may be said, the pop artist takes the mass-produced image and translates it into another idiom where – if the translation has been successfully accomplished – it will be charged with new energy and meaning.

By contrast – and for all his interest in popular culture – Smith's starting point is essentially the manipulation of paint, form, colour as things in themselves. What his wider interests have led him to, as we have seen, is an exploration of the new sensibilities that have resulted from exposure to new techniques of visual communication – but an exploration *in terms of painting*. Thus he has been led to extend the art of painting towards these new sensibilities and here his importance lies. This is not to say that an orthodox pop painter is unable to extend the art of painting but his motivating force would be the accommodation

of his imagery rather than exploration of sensibilities and this would give his work a very different slant.

In his recent work, Smith's painterly interests have in fact edged out overt references to the ad-mass world. This is by no means a regression or a denial of his earlier paintings; the shaped and extended canvases – originating as a means of exploring popular media – have proved to be of great interest to the artist in their own right and in the recent past he has been exploring *them* for their own sakes. This has been a perfectly logical progression. Once he had translated the new sensibilities into his own medium there was no longer any reason why he should tie himself to their incidental subject matter.

Certain works, such as *Ring a Lingling* (Figure 19), capitalize upon the gentle three-dimensional shapes formed when canvas is stretched over a shallow box-like framework of irregular depth. The dimensions of the framework virtually dictate the appearance of the finished work. Only two choices are involved (though, needless to say, these are vital choices) – the artist decides upon the structure and measurements of the framework and selects his colours (which are applied uniformly and strictly in conformity with the topography of the canvas). Everything follows from that. The dimensions of the framework can be varied on a modular basis so that a series of mathematically related paintings will result – none of which should, theoretically, be preferable to any other.

It is tempting, when viewing these three-dimensional works, to talk of bridging the gap between sculpture and painting, but Smith is not concerned with this. If he does not produce what can strictly speaking be called easel-

paintings he is still operating within that tradition. The concept of the picture plane is vital to his work – all his paintings are meant to be seen from one angle only. This is best illustrated by paintings done in 1964/5 which are so narrow and deep as to seem, almost, columns or buttresses. In fact they are concerned with his old theme of focus – the forward vertical plane being the picture plane, the striped convex plane the curve of focus (Figure 17).

In retrospect we may conclude that Smith, being English, did not have the impulse, typical of his American contemporaries, to push on from the schema of Abstract Expressionism to either a new kind of figuration or to a search for some purist absolute beyond, even, the purism of De Stijl. Smith was able to advance without having to commit himself totally to any party. At the same time he differs from the Phillips–Boshier–Jones wave in English painting in that he had several years of painting in an abstract idiom behind him before first coming into contact with American Pop. Both these facts may have influenced the very personal development of his art.

Dick Smith's work represents an original liaison between the fine arts and the world of mass media. He has established contact in purely painterly terms and in doing so has opened up new avenues for the artist to explore.

4 · Joe Tilson

b. 1928

At his first one man exhibition, in 1962, Joe Tilson showed wood reliefs and collage panels made during the previous two years. The wood was generally unpainted; the artist relied on the natural textures and architechtonic qualities of the structures. The titles however hinted at other layers of meaning. Some titles – *Elvin, Cannonball, Epistrophy, Giant Steps* – suggested links with the jazz world of the period in which the cult groups were those of Miles Davis, Coltrane and Monk. There were titles at once historical and emblematic – *Cortez meets Montezuma, Baron von Richthofen.* Others had a more contemporary ring – *Venus Probe, Shaftesbury Avenue* – whether speculative or urban. The titles overlaid the structures with a texture of language beyond the intrinsic language of aesthetically balanced joinery. The structural concerns which were the justification of the plain reliefs have formed the material basis of his work since that time, but Tilson has continued to overlay these structures with richer and richer stratifications of language.

The first evidence of this enrichment was given in certain painted reliefs of 1962 – *Phalanx* and *Odeon,* for example. Here the structural devices of the earlier plain reliefs were retained but colour was used to translate them into a new

and now specifically emblematic idiom. In *Odeon* (Figure
20) explicit references to an urban iconography are made;
the critic Robert Melville has described this piece as 'a sort
of triumphal arch for a ticket kiosk'. These 1962 reliefs
have something in common with the billboard paintings
which Richard Smith had begun at about the same time,
in so far as they are concerned as much with the sensibility
of the new urban lyricism as with its imagery. For Tilson
they represent a transitional phase and his mature idiom
first appeared with the series of 'boxes' which followed
(the box theme seems to have obsessed recent British
art).

Joy-Box was started towards the end of 1962 and the
cycle continued through the next year. Pieces like *Key-
Box* and *Vox-Box* add to what was, by now, quite specific
imagery another new element: the word. It would be
incorrect to say 'the written word' since this was concerned
not with calligraphy but with the concretization of the
word such as one finds on posters, billboards, shop façades,
or surmounting cinemas. No one in Britain – except, in a
rather different way, Peter Blake – has made such explicit
use of this phenomenon and it gives us a clue to the whole
of Tilson's art.

The advertising sign is an example of a medium which is
at once both literary and plastic, lyrical and monumental.
A single word may be detached from all syntactical context
without surrendering its meaning. On the contrary, the
word gains in potency since in this suspended state it
remains open to all possible patterns of syntax; read, even
involuntarily, it triggers whole chains of association. At
the same time the concrete realization of that word is a

plastic exercise allied to painting or sculpture – linking up with quite different strata of meaning.

This everyday and apparently simple ambiguity represents, in fact, a sophisticated concept. Transferred to a fine art context its potential is enormous and it is precisely this transfer that Tilson has achieved. In each of the two versions of *Key-Box* a large metal key hole is situated above the word KEY which is painted in heavy block capitals. The letters are given a *trompe l'oeil* illusion of three dimensions; in the smaller version they are themselves decorated with stylized waves and sky, adding yet another layer of ambiguity. In other pieces the letters are actually solid – carved in wood. The word functions as both comment and plastic device but, beyond this, it charges the whole piece with its own ambiguity. Ambiguity is apt to sound a negative value but here it is used to positive ends. In these boxes Tilson is exploiting the paradoxical conjunction of differing sensibilities; *Key-Box* is at the same time concrete image and poetic metaphor. The tensions contained within this paradox are forces which have sustained Tilson's art up to the present time and we may note that the box series was the occasion for the first exploration of the Ziggurat theme which has been the subject of his most recent work.

Within this climate of paradox, the relationship between different idioms and different conceptual patterns can be explored. In *Vox-Box* the word BOX is placed beneath a stylized mouth stuffed with exclamation marks. As in the classic billboard technique, visual and verbal image come together to form a multi-dimensional metaphor. In *Lucky Six* – a work contemporary with and related to the box

series – the visual centre is a two-dimensional representation of a six-faced object (a playing dice, seen here as a hexagon). The three visible faces are marked with dots – 3, 4, 5. Below them is the word SIX carved in wood. There is, therefore, a sequence from 3 to 6 – but a sequence which shifts from one idiom to another. A further paradox is introduced by the fact that SIX – a mere word – is turned into a plastic object while the dice – solid in reality – is reduced to the status of a representation.

Lucky Six leads naturally to another of Tilson's constant preoccupations: games. Also contemporary with the box series is a piece titled *Astronaut Puzzle* in which triangular sections can be rearranged until the intended pictorial solution is arrived at. Generally, however, Tilson's games cannot be played in quite such a literal sense. In a later series of painted reliefs to which he gave the generic title *Geometry?* he takes a fixed grid (the word GEOMETRY rendered in a stylized upper case face which might have been borrowed from the façade of a thirties cinema) and overlays it with random elements – in this case coloured discs. The letters – which may not be immediately deciphered – take on a symbolic quality; they appear to belong to the same family as card faces and chessmen. The three-dimensional nature of these pieces induces the sensation that the various parts could be moved – reorganized, as with *Astronaut Puzzle,* into other configurations which would provide a solution to the problem that the present arrangement seems to pose. But the game is in a state of physical check. It can only be explored in the mind. This exploration evokes a whole range of linguistic questions. It involves the syntax and grammar which underlies a

profusion of pictorial dialects; and we are led to investigate
the configurations of choice and chance on which artistic
expression turns. At the same time, of course, *Geometry?* is
still capitalizing upon the paradox which surrounds the
relationship between poetic metaphor and concrete image.
This is a linguistic paradox and its machinery meshes con-
vincingly with that of Tilson's language games.

Key-Box and *Geometry?* display these ideas in a fairly
straightforward way. In other pieces, such as *The Nine
Elements,* the meshing of the different layers becomes a
creative device in its own right, allowing elaborate configu-
rations of imagery – eyes, watches, fingertips – to combine
with purely semantic elements in such a way as to produce
language games of considerable complexity. Perhaps the
most elaborate of these games was *A–Z* (Figure 21), in
that it involved not only Tilson but many other prominent
members of the English art world. Tilson prepared a large
compartmentalized box topped by a sunburst which was
blazoned with the title. Each compartment of the box was
labelled – in solid upper case blocks – with a letter of the
alphabet. Artists were invited to contribute miniatures of
one kind or another to fill the appropriate compartments,
the distribution being determined by alphabetical prece-
dence using the initial of either surname or Christian name
(thus Eduardo Paolozzi's aluminium wheel occupies the E
spot whereas Richard Smith's foreshortened tube is classi-
fied under S). Other contributors included Peter Blake,
Clive Barker, David Hockney, Harold Cohen, Allen Jones,
Ron Kitaj, Peter Phillips, Richard Hamilton and Anthony
Caro (an index was provided in one compartment). The
stylistic complexities of this construction reflect in a

novel way the preoccupations of Tilson's more orthodox work.

His ability to handle elaborate structures has led to him being asked to take on various large-scale commissions. The 1964/5 mural *Capital* for the Royal Garden Hotel in Kensington was an enormous exploration of the *Geometry?* theme, making intelligent use of an awkward wall space. The mural is extremely long and narrow and relies upon a narrative quality, almost like a Chinese scroll – except that here the narrative is fragmented, independent of sequence and non-figurative. It is something like an adventure in symbolic logic. A comparable but more overtly decorative project was his interior for the dome of the British pavilion at the 1964 Milan Triennale, and he entered the commercial field with his metal advertising sign for a popular brand of gin, situated for some months at Piccadilly Circus.

Prints have afforded Tilson the opportunity to explore complex linguistic ideas on a smaller scale. In 1963 he produced a screenprint, *Lufbery and Rickenbacker,* which represents a departure in that he employed photographic imagery for the first time. The screen-printing process (like so many other British artists he has collaborated with Christopher Prater of Kelpra Studios) offered many new opportunities. As well as suggesting new methods of approaching existing themes it introduced the possibility of making a very direct use of photographic material; and by allying screenprinting to the potential of vacuum-formed plastic Tilson was able to pursue the three-dimensional aspect of his work in a new and flexible way. Further explorations in the *Geometry?* series resulted from these new techniques (Figure 22); in *Two Wrist Watches* the

formed polystyrene is vacuum metalized. At the same time, in his own studio, he was exploring quite different concepts. Contemporary with the photographic and vacuum-formed prints were his series of *Conjunctions* – free-hanging mural reliefs – and the hand-made ziglical* reflector columns (there were also multiple versions) which represent the austerest investigation of the purely plastic aspects of his work which he had made since the plain wood reliefs of 1960/1; so austere, in fact, as to suggest links with New York minimal art. These reflector columns have something in common with Brancusi's endless columns but – instead of being purely sculptural – they utilize a mirrored back-plate and base to complete the illusion. Tilson has not chosen to go any further with this extreme of abstraction. What is interesting is the degree of feedback that is apparent between his exploitation of the poles of abstraction and mechanically reproduced imagery. One of the photographic prints – *PC from NYC*: a long, folding postcard featuring paintbox coloured views of New York – proves, on investigation, to be a ziglical column overlaid with imagery. This process of feedback is significant. It is from such mutually responding forays across the whole range of modern art (and beyond) that Tilson's central themes have been synthetized.

Just such a theme is the Ziggurat (Figure 23), or Zikkurat, round which so much of his recent work has revolved. Tilson was first drawn to the Ziggurat theme when reading of the Spanish conquest of Mexico and soon

* The adjective 'ziglical' is derived from 'ziggurat'. Tilson's interest in ziggurats – the stepped pyramids originating in ancient Mesopotamia – is discussed further in this article.

became fascinated by its universal relevance. The available examples range from the hieratic structures of ancient Mesopotamia to the twentieth-century fantasies of Sant' Elia and Hugh Ferris. The whole skyline of Manhattan is a vast proliferation of the Ziggurat theme (some of Tilson's screenprints feature such prominent features of this skyline as the Empire State (Figure 24) and Chrysler buildings). Again the Ziggurat has entered into contemporary folk-art by way of the biblical films which pour out of Hollywood, Spain and Italy. The lettering on many of Tilson's Ziggurats – monumental block capitals casting long, dramatic shadows – reflects the idiom of credit titles favoured by the producers of these cinema epics. The lettering on some of the most recent Ziggurats, however, imitates punch-tape – introducing another speculative dimension. And always, beneath the particular, remains the universal symbolism of the Ziggurat with its residues of ritual violence and primitive religion. At the same time the Ziggurat gives Tilson a pre-existing language – or, rather, a complex of pre-existing languages – which can be exploited autonomously within the traditions of modern art.

The Ziggurat is a metaphor which has been made concrete a thousand times. Tilson's achievement is to have distilled from the cross-tides of reference which surround the metaphor the exact variant of the icon that is appropriate today. Like so many other English artists of his generation he excels as a manipulator of complex language patterns. This defines the character of his work and the character of what is most lively on the London scene today.

5 · Peter Blake

b. 1932

Peter Blake's work is perhaps marginal to the developments discussed in this book but he has, none the less, had a considerable influence on the character of the art scene in which these developments have taken place. For the general public he has been a focal point of British Pop Art – perhaps because his concern has been with *popular* art in a very straightforward and uncomplicated way (to the extent that he has become virtually a popular artist himself). Most of the other artists to whom I have devoted chapters have been concerned with analysis of popular idioms. In some cases they have emphasized the content of these idioms; in other cases emphasis has been placed upon an analysis of ad-mass presentation techniques. Blake's involvement with analysis has been minimal and incidental to his main interest, which is popular culture for its own sake. Blake wants, quite simply, to record his own engagement with popular culture. His subject matter does embrace mass media personalities – notably film and recording stars – but he is equally at home with the more traditional forms of popular expression such as might be associated with the circus, the fairground, the music hall.

Most of the artists in this book approach popular phenomena from the point of view of media manipulation – they

are primarily interested in how the image is transmitted to the audience. If they are dealing with, for instance, a cinema subject, they tend (I over-simplify slightly) to identify with the director. Blake, on the other hand, identifies with the audience. Rather than concern himself objectively with an analysis of presentation techniques he has been involved with the sheer impact of the Pop image in a far more subjective way (Figure 25).

Perhaps the most technically influential of Blake's works have been the collage constructions such as *The Love Wall* (1961) in which photographic images – postcards and glamour pictures – were organized against architectural fragments like so many pin-ups tacked to a door. These constructions did not exploit traditional fine art formulae: they used unexpected imagery in a very frank and direct way, and they had a considerable impact on his younger contemporaries. Although taken in retrospect, they can be seen to fit very comfortably into the overall pattern of Blake's work, these constructions seemed at the time to be rather radical in concept and perhaps even to relate to Rauschenberg's assemblages which were then becoming known by way of reproductions.

Blake probably made his main impact on other artists in the years 1960–62. His influence consisted mainly of making the younger artists aware of the possibility of using Pop material in a fine art context. In their subsequent development they tended to move further from him. It should perhaps be noted that these younger artists were, at this time, largely unaware of the experiments that had already been carried out by, for instance, Richard Hamilton. At least three different groups of British artists discovered

he possibilities inherent in Pop imagery independently of ach other and over a period of several years. The different treams began to react upon one another only at a later tage.

During the past five years or so Blake has continued to efine his personal vision – largely within a traditional fine art context (Figure 26). Some of the pictures exhibited at his 1965 exhibition did make a feature of collage elements but only in addition to very straightforward painted images. *Doktor K. Tortur*, for instance, is a portrait of an imaginary wrestler surrounded by trinkets related to his professional persona. These include a toy Mercedes, a cigarette holder, German coins and a guide book to the Rhine. Other subjects treated at this time included Jean Harlow, various imaginary strippers, Simon Rodia (the Italian tile-setter who built Watt's towers in Los Angeles) and the Beatles (Blake was later largely responsible for the cover of their Sergeant Pepper album). All these paintings were marked by a strong humanizing tendency. Painting a film star, Blake is interested not only in the screen image but equally in the reality that lies behind it – in the human being around whom the fantasy has been built. He returns the celluloid image to the flesh (and he has remarked that he only paints a celebrity from a photograph because the person is not available to sit for him).

This humanizing tendency is very much in evidence in a group of paintings, titled – in each case – *Pin-Up Girl* (Figure 27) which he completed in 1965. Robert Melville has remarked of these that Blake 'finds human warmth where others find only cliché and exploitations'.

More recently Blake has been working on a number of

larger canvases. One takes as its subject matter a vast Hollywood sword fight (in which the participants are not limited to the usual swashbuckling specialists). Another portrays a Californian family acting out Tarzan roles in their suburban interior. A third is a version of the Mad-Hatter's Tea Party (with an all-star cast) and a fourth is a portrait of David Hockney in a Beverly Hills Spanish setting which also accommodates a fantasy companion.

These are perhaps the most ambitious works which Blake has attempted to date – certainly the most complex. All that can be said at this moment is that they represent a logical step in his idiosyncratic but consistent development. It is probable that this development will take him still further from the mainstream of activities discussed in this volume. At the same time, this should not be taken as detracting from his original contribution or from the intrinsic merit of his work.

6 · Adrian Berg

b. 1929

Marshall McLuhan has suggested that modern systems of communication have led to our becoming retribalized on a world scale. Cinema, television, saturation advertising and photo-journalism have resulted in the trans-continental spread of a new, non-verbal Esperanto. This emergent tribalism has not replaced existing sensibilities – those of the Gutenberg era; rather it has added to them another – and still transparent – layer of sensibility. No one would dream of judging minimal art by the standards of the Renaissance. It is equally absurd to approach many aspects of European painting with critical software geared to recent American developments (which is not to say that there is not a conscious and sometimes embarrassing overlap which on occasion makes comparison inescapable). The differences between American and English Pop Art provide a useful example. An artist like Oldenburg has been involved primarily with an environment; a painter like Richard Hamilton has been concerned with a media landscape. Oldenburg is engaged in a physical situation; Hamilton is dealing with a sensibility bombardment, the material source of which remains at several removes from him. The psychological perspectives differ radically. The non-American coming to terms with popular culture must

adopt something equivalent to the inverse perspective
which the Byzantines used to portray a God-centred
Universe. English Pop Art was more fruitful than its
continental equivalent because it was able to accept this
notion and the idea of the media landscape. The Beatles,
for that matter, display a similar detachment – not copy-
ing American models but re-creating from the transmitted
sensibility a wholly original language. Continental Pop
Artists generally attempted to deal with their own environ-
ment using the syntax of American art as a crutch, an
approach which led inevitably to provincialism.

Once you have accepted the idea of a media landscape
there is, of course, no reason why you should confine the
notion to ad-mass media. Literature, the fine arts in gene-
ral, science can then be treated in a similar way. History
of Art can replace Hollywood as the centre of the universe
(we may recall the last chapter of Pantagruel with its
reference to 'that intellectual sphere, whose centre is
everywhere and circumference nowhere, which we call
God'). Most of those who make a god of History of Art are
too naïve to comprehend the problems of perspective that
this involves. Deprived of this awareness their artifacts will
seem merely anachronistic. But an artist skilful enough to
devise or discover such a system of perspective could make
statements within an historical dimension which would be
of consequence today. It is something of this order that I
am suggesting that Adrian Berg is attempting to do.

Berg has written: 'Time was when a painter could with
a title evoke whole mythologies, whether Christian or
pagan. Now he has only fragments of a mythology, called
art or science or, on this green island, nature.' Here is a

clue, I think, to the perspective device that we should be
looking for. Much has been written about fragmentation in
modern painting and there is no need to recapitulate
(though it is interesting to note that many American
artists, dealing with a contemporary and physically
immediate situation, have no commerce with fragmenta-
tion). Berg is a rarity, however, in that he is consciously
dealing with the fragmentation of ideas. This corresponds,
perhaps, with the emphasis placed by English philosophers
on linguistic analysis. The existential bias of most conti-
nental philosophy is paralleled by an emphasis on the
fragmentation of phenomenological states.

Even when coping with matter taken from another
dimension – the historical in this instance – the artist's
language remains autonomous and imposes its own vali-
dity. In any case fragmentation is only part of a total
pattern. The artist who grasps historical perspective can
infer a whole cultural system from the trajectories of its
fragments.

When Berg paints a landscape he is not merely echoing
the great landscape paintings of the past; he is exploring
the possibilities that this tradition offers when projected
into the present. The exploratory nature of these paintings
is emphasized by the fact that a number of the canvases
are divided into as many as a dozen sections in each of
which the same fragment of landscape will be portrayed in a
slightly altered manner. The ostensible subject of the
painting may be a pathway between trees but the starting
point is in one very real sense the language of landscape
painting. Linguistics precede the physical response. This is
not to say that sensual retinal responses are absent; this

could not be so since the language is geared to such responses. I am simply describing what I see as being the method of procedure; the balance on the canvas remains unchanged.

L'enfant et les Sortileges is not strictly speaking a landscape painting but has some bearing here. In a catalogue note Berg remarks: 'Colette's libretto to this opera tells how a child's naughtiness transforms reality into fantasy. As fantasy threatens to make an end of him, a single act of kindness on his part returns him to reality the wiser. The best moment for me is when the scenery lifts and Ravel's music transforms the bare stage into a garden.' In portraying this moment the artist takes the pre-existing language of painting and uses it to evoke his subject in a way analogous to that in which the composer employs the pre-existing language of music.

The European tradition of landscape painting meshes, of course, with the traditions of Western science. We may recall Constable talking of painting as a branch of natural philosophy. Berg takes as the starting point of a painting called *Five* (Figure 28) the following quotation from Martin Gardner's *More Mathematical Puzzles and Diversions*: 'The logarithmic spiral is intimately related to the Fibonacci series (1, 1, 2, 3, 5, 8, 13, 21, 34 . . .), in which every term is the sum of the two preceding terms. Biological growth often exhibits Fibonacci patterns.' At the centre of the canvas is a mathematical construction. Grouped about it are variously complex geometrical and organic forms based upon this construction. Here the language of mathematics, with all its implications, is taken over by the artist and translated into an autonomous plastic event. A similar

preoccupation is shown in another recent painting, *Polyominoes* ('By this is meant a set of squares joined along their edges ... There is only one type of domino, two tominoes, and five tetrominoes. When we turn to pentominoes (five squares) the number jumps to twelve. . . . There are 35 distinct varieties of hexominoes.') One of Berg's latest canvases deals with the subject of multiplication; an earlier painting was titled *The Platonic Solids*.

Allied to this concern with mathematics is an interest in games, (another recurring factor in British art). In *Snakes and Ladders* (Figure 29) Berg takes a pre-existing language, loaded with accumulated symbolism, as the basis for his painting. This can be seen as a schematic exploration of his more general themes. Comparable, but much broader in scope, are the cartographic paintings. *Europe by Rail* (Figure 30) is divided on a grid system into thirty-six squares in each of which is the map of a European city (London occupies two squares). The name of each city is stencilled on to the appropriate map. Jasper Johns's paintings of the U.S.A. spring to mind. Johns seems to be exploring a basically phenomenological problem – the physical tension between painting as representation and painting as an autonomous physical object. This enters into Berg's painting, but only incidentally. The use of maps gives him another pre-existing language, precharged with layers of meaning – both personal and general. This enables him to handle very hot material in a very cool and detached way (each map is, in itself, a delicate calligraphic statement). Detachment of this kind is essential to establish the kind of perspective which Berg requires; but I must emphasize that this perspective does

not exclude the possibility of personal statement. His map painting *San Francisco* is intimately related to his own first impression of that city.

Suggestions have appeared lately which propose that Freudian analysis can be most profitably considered as a system of semantics. When Berg painted *Freud's the Early Application of Religious Influence* he was, I think, giving plastic expression to a notion of this kind. On this large canvas the human brain becomes the playground for a proliferation of visual languages. These are not arbitrary statements – rather they represent a calculated accumulation of ciphers and symbols – but they are used for their own sakes, with a kind of controlled autonomy. One can imagine that a philosophical system might be derived from a study of the terminology of earlier systems – the words, subject to the distortions of choice and chance, imposing a new syntax upon themselves which in turn lends them an unsuspected set of meanings. Perhaps it is in just this way that systems do arise – unconsciously – and a process of this sort is simulated in the Freud painting. Pre-existing language patterns are pushed into new configurations. The form of the painting is allegorical and here again it demonstrates the linguistic bias of English art. It is totally removed from the sensibility of 'classical' modernism. It does not attempt to 'express' a phenomenological state as might an Expressionist or Surrealist painting, each in its different way; rather it finds a linguistic equivalent for that state.

The whole idea of allegory is alien to what passes for the contemporary sensibility; but there is some danger here that we may be confusing sensibility with critical cliché. If

we accept that Berg's position is valid – which I think we must – then we must also accept his use of allegory since it is the logical extension of his method, given certain complex subjects which are the logical extensions of his artistic interests. He has, in fact, painted allegories which are still more explicit than the Freud canvas: *The Combat*, for example ('Edwin Muir's poem of this title describes a combat between what is well adapted to fighting and what would be its victim, in which the outcome is nevertheless uncertain . . .') and *The Muse Beset*. We may understand Berg's painting more easily if we think of Brecht whose concept of theatre – cheerfully canonized within the orthodoxy of the contemporary sensibility – was deliberately biased towards the allegorical in order to distance the audience, to make it think instead of feel.

It would be unwise to push the parallel with Brecht beyond this technical device. Berg's position is nearer to that of another literary figure – the poet Cavafy. Like Cavafy, Berg is an artist dealing often with the past, but in terms of the present; re-phrasing the values of an old culture in such a way that they may contribute to the new synthesis.

7 · R. B. Kitaj

b. 1932

R. B. Kitaj's background is very different from that of
most of the artists discussed in this book. He was born in
Ohio and had studied at New York's Cooper Union and in
Vienna before arriving in England in 1956. This difference
in background is matched by a considerable difference in
intellectual outlook; but the fact remains that Kitaj has
been a major influence on British painting in the sixties.
At the Royal College of Art he was a contemporary of
Allen Jones, Peter Phillips, David Hockney, Patrick
Caulfield and Adrian Berg and had an effect upon all of
them (with the exception of Berg, these painters were
several years Kitaj's junior), either directly or indirectly.
In a more general way, Kitaj's influence has been felt by
the whole of the British art world.

Kitaj arrived on the scene during the period in which
most younger British painters were still trying to come to
terms with Abstract Expressionism and its immediate
derivatives. There was, it's true, an embryonic interest in
the work of such American artists as Johns and Rauschen-
berg whose work was becoming known (in reproduction at
least); but most younger artists in Britain were struggling
with the implications of Pollock, De Kooning, or post-
painterly abstractionists such as Kelly. At the same time

some were beginning to realize that this American art could not be translated directly to suit a European context – at least not without appreciable loss. For aspiring painters who had reached this point of awareness, contact with Kitaj was extremely valuable. His familiarity with all aspects of modern art, combined with his broad intellectual and sociological interests, had led him to evolve a new and flexible kind of figurative art which offered a viable alternative to the prevailing conventions of advanced painting (Figures 31–3).

The influence which Kitaj had upon these young artists was effected at both a practical level and at the level of general example. I mean by the latter that Kitaj's example helped some of the younger artists to gain the courage to incorporate their personal interests into a new kind of figuration (interests which were often very far from his own). On the practical level, Kitaj's art contained many suggestions as to how this new kind of figuration might be evolved.

Kitaj was not specifically concerned with ad-mass material – certainly not in the way that Richard Hamilton, say, has been – but he was quite prepared to make use of it wherever he thought that it was necessary or relevant (and this has continued to be the case). He remarks that one is affected by a great deal of what is happening around oneself, including photography and the cinema, and that one of his great hopes is to bring painting itself to the pitch of interest attained by the film and photography. So far as his younger contemporaries were concerned the fact that he was open to the inclusion of this kind of material must itself have been of great significance. For Kitaj it seems to

have been an incidental device, a way of coming to terms with certain aspects of the wide range of material he has treated.

The scope of Kitaj's interests can perhaps be best described by quoting from some of his own catalogue notes.

Nietzsches Moustache: 1962
'In their reaction against Hitler's authoritarianism, German universities since the war are given to punctilious observation of democratic procedures; and during the past years the faculty of one great university after another had to reject by solemn vote an offer for the sale of Nietzsche's moustache, allegedly severed from the corpse before burial.'

from 'Nietzsche and the Seven Sirens' by Walter Kaufmann, Partisan Review May–June 1952.

Tédéum: 1963
This picture was partly suggested by a photograph of a scene from a New York production of Sartre's 'No Exit' (c. 1946). Some of the detail derives from an immense picture-book called 'Present-Day Impressions of Japan (1919)' and the giantist figure on the right had its source in a drawing of the young Goethe at a window in Rome reproduced in 'Goethe und Seine Welt in 580 Bildern', Leipzig 1932.

The Perils of Revisionism: 1963
I think the phrase is Galbraith's. At first this painting was called 'Value, Price and Profit' after a pamphlet I hadn't read but I didn't want to have *particular* analogies drawn between the terms of the title and the three figures and I wanted the picture to smell somewhat of these imperfections in the world with which professional economics is often moved to treat. Paul Manship's famous statue 'Buddies' has always remained

in my thoughts for some strange reason and I believe this
picture began with 'Buddies' in mind. The painting developed
with three figures instead of two and some of the details were
suggested by plates in *Scientific American* and other magazines.

The Republic of the Southern Cross: 1961
Closely associated with the 1st movement of the 9th symphony
which Berg called 'the most heavenly thing Mahler ever wrote'.
There are borrowings here from magazine reproductions of
work by M. Rosso, B. Fuller and F. Stella aside from fragments
of early paintings of my own.

These catalogue notes, plus the texts which Kitaj on
occasion incorporates into his paintings and prints, have
led some perceptive critics to discern a literary quality in
his work. As far as some catalogue notes are concerned,
Kitaj is amused that they have been taken so seriously. If
Kitaj's work is literary it is so in the sense of being poetic.
Some observers have been tempted to look for 'meanings'
in his work – 'meanings' such as might be found in a
treatise on venereal diseases, their variety and incidence
amongst the floating aboriginal population of Darwin. Such
a treatise might well trigger off some creative response in
Kitaj's mind but the result would not lend itself to the same
type of analysis as its source; inevitably, since Kitaj's
paintings and prints are concerned with poetry.

Kitaj has said that the impact of his work relies upon
shared experience but his ambitions tend towards specifi-
city – specificity of statement, specificity of source. Talking
of his use of photographs, he remarks that

The *strangest* photos have not entered into my confidence *often*,

though I'll keep them on. It's just that the macabre lives *less* well in my experience, looms less large over some years than alternative modes ... but ideas can prosper there – essence, character *are* found there ... *Specificity* knows no poetic borders and poetry knows *only* specific occasion ...

Elsewhere, he includes in a title the thought that poetry is an instrument of research (the word 'poetry' he places in brackets).

The important thing to keep in mind is that Kitaj's poetry is conceived in primarily visual terms (though certainly his use of written texts helps to give it an extra-plastic dimension). He is a printmaker and painter and it is as such that he should be judged. The fact that his compositions open onto a broad intellectual vista not usually associated with the plastic arts should not be allowed to cloud the issue.

Kitaj's paintings display his extensive knowledge of the idioms of modernism but he places an emphasis on the painting of figures – an emphasis which may seem curious at this juncture in the twentieth century. 'Of all my hopes,' he says, 'my hope for forging a great figurative art is certainly the greatest.' He prefers that his art should touch 'the illustrative, the vulgar' than that it should risk the anonymity that he sees in much modernist art (and here he is referring not so much to abstraction as to 'a corrupt figure tradition'). He talks of Charles Olsen's concern with high energy construction in the making of a poem and aims for something similar in his proposed figure art. He quotes Giacometti's phrase 'the head is sovereign' and adds 'it is for me too ... So that that moment when modernist arrangement meets the need to describe the

side of a head ... will be a great and condensed poetic moment and, I hope, the beginning of as much worldly scope on a canvas, say, as one can imagine.'

Kitaj's printmaking is rather separate from his painting activities. The screenprint, with its ability to reproduce photographic and other pre-existing material, lends itself, as he points out, to more vicarious kinds of satisfaction than painting. Printmaking is for him nearer to a journalistic activity. He uses the medium as a flexible kind of notebook – putting down ideas that have not found their way into paintings and which might otherwise be lost (Figures 34 and 35).

8 · Peter Phillips

b. 1939

In 1961 Peter Phillips painted a canvas which he titled *For Men Only starring MM and BB* (Figure 36). The imagery – a stripper, a hare that seemed a fugitive from some pinball machine, the collaged heads of Marilyn Monroe and Brigitte Bardot – was novel; the composition and treatment had an unmistakable freshness. Previously Phillips had painted, briefly, in an abstract expressionist style, but this idiom had not suited him. There is no indication that the shift to his own distinctive brand of figuration was dictated by any one event or influence. The exchange of ideas among his contemporaries at the Royal College of Art – they included David Hockney and Allen Jones – encouraged experimentation; Ron Kitaj was demonstrating that a wide range of imagery could be accommodated within a wholly modern frame of reference; and reproductions of work by Johns and Rauschenberg were beginning to circulate.

All this helps to explain the acceptance of a new sensibility but does not really tell us why Phillips's work developed in just the way it did. An important factor was that his previous art training had included instruction in technical drawing and commercial art techniques at a Birmingham school where the staff were geared to the

methods of the thirties and forties. Freed from stylistic
inhibitions he now felt able to utilize these idioms once
more (having always enjoyed their crispness and precision).
He was perhaps encouraged in this taste by the hard-edge
abstractions of the Situation* group which was deployed,
at this time, around the critic Lawrence Alloway. Unlike
this group Phillips did not feel motivated to eliminate
imagery from his work. In fact it was rather as though a
return to the technical disciplines of his Birmingham days
had brought a return to the imagery which had engaged
him during that period. From 1961 onwards his paintings
were immediately recognizable. Sometimes appearing
through cut-out circles and stars, the archetypal icons of
Pop Art – pin-ups, car stylings, motor-cyclists – would be
organized with a demotic panache into a tight-knit com-
position. The strong sense of pattern combined with lyrical
juxtapositions of imagery to create a highly personal
idiom.

There is no harm in thinking of Phillips as a Pop artist
if we keep in mind that Pop Art is a movement quite un-
like any other. It is not a narrowing of focus in response to
the problems of one historical moment; it is, rather, an
abolition of snobberies which gives the artist access to a
new range of sensibilities.

Quite apart from its imagery, Pop Art introduced a new
technical sensibility. Phillips has observed that technique,
as much as anything else, can be the subject of a painting.
Now – having arrived at a personal idiom – he pursued an

* The Situation group included John Hoyland, Robyn Denny,
Richard Smith, Bernard and Harold Cohen. They exhibited, as a
group, in London in 1960 and 1961.

aesthetic of technique. From a very early stage in his career, the compositions seemed to result directly from a logical exploitation of the technical devices involved. We may say that he arrived at a language which became wholly autonomous. In this language, image and technique were integrated, providing him with a vocabulary and syntax which relieved him of the chore of striving for effects and which gives his work its consistency. To simplify things slightly we could say that Phillips took the imagery and techniques of the ad-mass world and used them for their own sake but with the flexible logic of fine art. The autonomous nature of these paintings gives them something of the character of games – a concept which itself integrates well with the whole nature of Phillips's art.

In 1964 Phillips moved to New York on a Harkness fellowship and the economic freedom which this allowed him enabled him to pursue the logical implications of his work with still greater rigour. For some time he had considered using an airbrush. Now he acquired one and began to use it for the major part of his work. Using a machine was a logical, almost inevitable, extension of his earlier painting methods. Perhaps as a result of the airbrush techniques, the imagery became bolder and still more direct. Earlier, in 1964, he had painted the first of his canvases to be titled *Custom Painting*; now its promise could be fully realized. Formalized car grilles, coils, machine parts, were organized against patterned grounds into a complex governed by laws of symmetry which were the logical products of the artist's technical preoccupations. This constitutes a kind of teleology of

method in which the realized composition is held in
potential by the choice of imagery and technique.

If we accept this notion of a teleology of method we
must recognize the importance of the choice of imagery.
Phillips's imagery exists as a metaphorical equivalent for
his methods. The imagery is integral with the method (it is
difficult to imagine him painting *in the same style* but
drawing upon a different range of icons). We are con-
fronted here with an issue relevant to the whole of the
Pop Art phenomenon. A figurative artist who wishes to
make original formal statements must involve himself
with a particular range of imagery if he hopes to avoid
contradictions of tone (though, of course, such a contradic-
tion could be consciously exploited). The use of ad-mass
imagery is not gratuitous within the context of the media
revolution. To this must be added the remark that con-
cern with this imagery involves the artist with the tech-
nology of communication.

Communication is not essential to the central values of
art which has at all times been dependent for its power
upon the skilful manipulation of formal qualities; but this
is not to say that the technology of communication is
irrelevant to the situation of the artist today.

An artist may rely upon his audience's familiarity with
the formal context within which he is working. Where this
is the case – as in much non-figurative art – the com-
munication threshold leading up to any given work will be
short. If the non-figurative artist lacks confidence in his
audience he may think it necessary to issue educational
material in the form of manifestos – disguised or otherwise.

The figurative artist, by contrast, introduces the tech-

nology of communication into his actual compositions. The use of familiar (or apparently familiar) imagery helps to bridge the gap between the language of every-day visual experience and the specialized language of the artist. The communication threshold is thus lengthened but the central concerns remain the same. The principal message of any work of art will be centred on its formal qualities. For these formal qualities to become fully effective the composition must exist apart from any illustrational material it contains (material which is the instrument of communication). Where this is achieved, a painting, drawing or print takes on an existence independent of any external factors – it becomes an object in its own right. In Phillips's work, the imagery presented may seem familiar but is removed from all suggestion of its normal environment. It has an independent existence as an organized complex of tones, colours, surfaces, forms. These, balanced against one another, add up to a totally self-contained plastic event.

A specific example of the relationship between method and imagery is Phillips's preoccupation with customizing. Since the original 1964 composition, many of his canvases have been titled *Custom Painting* (Figures 37 and 38) which reflects his interest in this American sub-culture and in a particular approach to the creation of a visual image.

Automobile customizers specialize in what might be called psychological streamlining – that is to say, configurations of lines and curves which suggest speed and power without necessarily any aerodynamic basis. In this sense a customized car is an aesthetic rather than a purely

functional object – it is conceived within much the same framework of considerations as an art work. The classical problem of form and content is transcended; the form is the content, yet the end product is not an abstraction. It is something concrete. The customized car represents a perfect fusion of method and image. One could not exist without the other and both are tied to a contemporary cultural situation. Phillips employs customizing imagery in a non-functional way, just as the customizer employs the visual side-products of aerodynamic streamlining. The use of imagery drawn from a contemporary cultural situation entails, within the fine arts too, the acceptance of an appropriate method of execution. The result, if the exercise is carried out thoroughly, will be a concrete entity as convincing as Starbird* coachwork.

During his initial stay in New York, Phillips collaborated with another English artist – Gerald Laing – in a very unusual project. They formed themselves into a market research organization – Hybrid Enterprises – and prepared elaborate kits containing various materials, colours, optical patterns; a choice of forms such as squares, circles, stars, chevrons. There were statistical sheets, and interviewees were also able to make free-hand contributions. These kits were given to a sample of critics, dealers, collectors (not artists); the data returned was processed by a computer and an object was built in accordance with the specifications which it furnished. To some extent the results obtained could have been predicted by intelligent guess-work. The materials favoured were polished aluminium, perspex – the glamour substances of the period.

* Starbird is one of the best known customizers in the United States.

The object was three-dimensional yet not strictly sculpture. Its scale was just below the human (smaller replicas were also built). But, beyond these generalities, the object had particular qualities and a very special character which could have only been arrived at by this impersonal, statistical approach.

Once more the finished product was implicit in the method chosen; but the autonomy of *Hybrid* and the autonomy of Phillips's paintings have one important difference. In *Hybrid* the artists' choice was confined to method – and this was a choice only in so far as it was a cultural gesture; the means of carrying out the survey were determined by purely objective considerations. The choice of substance (I use the word here in preference to content) was made by the interviewers and processed by the computers. In Phillips's paintings a method is rigorously pursued but it springs from a choice of substance made by the artist before the work is commenced. The *Hybrid* experiment highlighted this.

Phillips had previously tended to minimize the importance of imagery: 'The imagery is not important or significant in itself; it is the way that it is painted and used that matters.' Now he was inclined to think that he had underrated the importance of his emotional involvement.

It seems remarkable that the human mind has been able to adapt itself so rapidly to the amount and variety of visual experience with which we are bombarded today. Phillips's paintings capitalize upon the mechanism by which this adaptation has been made possible – uses this mechanism as a vehicle for art statements.

The mass of visual material is, without our always being

conscious of the fact, broken down into packages of highly specialized information. We only grasp completely certain areas defined by our own particular interests. The interesting fact is that we seem able to take so much for granted that falls outside these areas. The scanned image of the television screen, the tonal structure of the newsprint picture, the advertising artists' code for rendering chrome – these are the things we are really familiar with; and this familiarity with presentation techniques leads us to believe that we are equally conversant with the content of the image itself. Most of this content in fact slips past without the mind attempting to grasp it.

These presentation techniques constitute the technology of communication on which the ad-mass world depends.

Phillips has evolved a highly specialized range of imagery that encompasses the automobile, the machine, scientific diagrams, glamour poses (Figures 39, 40, 41). These images seem to be familiar but often turn out to be very unfamiliar in detail. The method of presentation, however, exploits familiar ad-mass techniques so that the observer's first reaction is one of recognition. This illusion of recognition is what involves the observer with the composition, or – more exactly – with a chain of devices which, when complete, constitute the composition.

The dominant adjective in twentieth-century art has been 'experimental' – suggesting some scientific or crypto-scientific connotation. A great deal of art – the abstract wing – is open to comparison with what is invitingly called pure science. The adaptation of art to the needs of publicity and decoration has produced a class of aesthetic

technicians. What has been missing until recently is an equivalent for that vital class of scientist – cyberneticists and the like – who are responsible for the liaison between the various pure disciplines, a liaison upon which new technologies are built. In aesthetic terms this liaison must reach out beyond the traditionally accepted limits of painting, since these limits represent only one area of pure research. Just as the originators of cybernetics were specialists in other fields – electronics, for instance, and mathematical logic – so it is reasonable to expect painters who are developing new disciplines to retain something of the bias of their original specialization. What seems certain is that it is just the relationship between matter and method which we find in Phillips's work that holds the promise of a new discipline. As the artist concerns himself with the imagery of the present he lays the foundations for the methods of the future.

Hybrid was a very American undertaking – but one conducted by outsiders. Phillips and Laing remark that they had the sensation of being both participants and observers. While Phillips believes that *Hybrid* has implications for the future, its most important immediate effect was to clarify his own position. A better understanding of his own motives has enabled him to pursue his method with increasing confidence.

His brief excursion into sculpture too has chiefly confirmed him in his knowledge of himself as a painter. There were certain problems which he could not come to grips with in two dimensions. Having done so in three dimensions he was able to return to the classic concerns of his

painting. The lyricism of much classical art springs from tensions set up between the powerfully irrational nature of the subject matter and the rational pursuit of the method which this subject matter suggests. Within this framework Phillips is a classical artist.

9 · Gerald Laing

b. 1936

The earliest exhibited works of Gerald Laing drew upon a
range of imagery which was archetypally in the Pop idiom
(Figures 42, 43, 44). His icons included drag-racing cars,
skydivers and pin-ups. These were treated less as subjects
for paintings than as vehicles for plastic explorations. The
image was reconstructed, tonally, in terms of painted dots
– simulating the appearance of a newspaper photograph.
These dots were painted freehand which gave them a
character very different from the Ben Day screened grids
employed by Roy Lichtenstein. The image was conceived
in black and white monotone but, occasionally, areas of
flat brilliant colour would be introduced onto the canvas.
These paintings shared a number of other qualities with
newspaper photographs. Generally they were a-composi-
tional; part of a limb, part of a vehicle, might be cut off
by the edge of the canvas in a way that could be described
as structurally arbitrary. The same type of a-composi-
tional image can often be found in the news photo where
topicality tends to be of more importance than conscious
aesthetics. Then again, Laing's skydivers and dragsters
partook of the same sense of unreality as do news photo-
graphs. Flattened to a programmed density of grey dots
the most violent tragedy may come to seem innocent. A

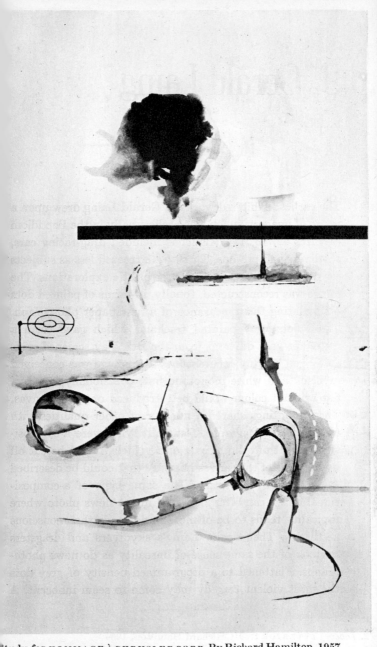

Study for HOMMAGE À CHRYSLER CORP. By Richard Hamilton, 1957.

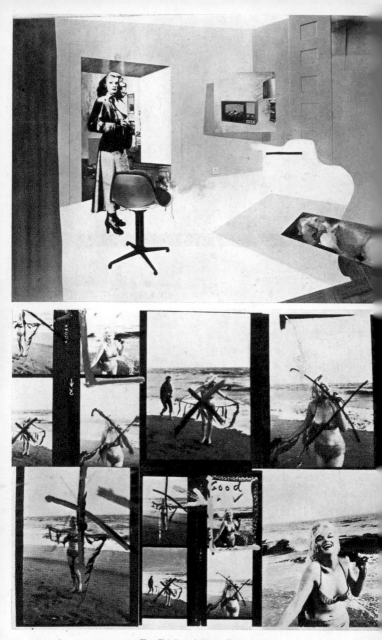

2. *(above)* INTERIOR II. By Richard Hamilton, 1964.
3. *(below)* MY MARILYN. By Richard Hamilton, 1965.

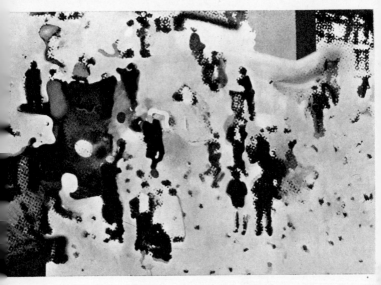

TRAFALGAR SQUARE. By Richard Hamilton, 1965–6.

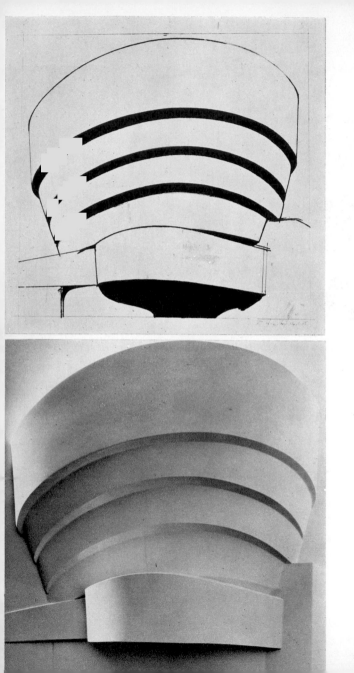

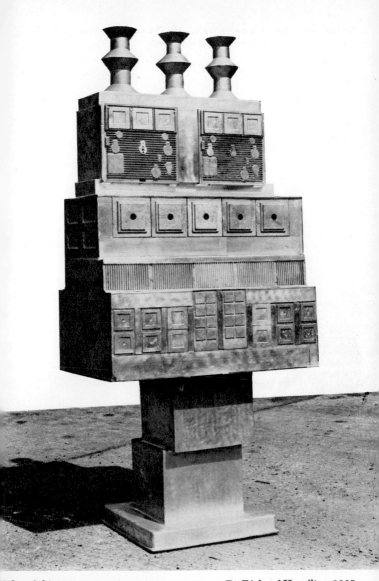

(above left) THE SOLOMON R. GUGGENHEIM. By Richard Hamilton, 1965.
(below left) THE SOLOMON R. GUGGENHEIM. By Richard Hamilton, 1965.
(above) THE WORLD DIVIDES INTO FACTS. By Eduardo Paolozzi, 1963.

8. *(below)* PISTHETAIROS IN IPSI. By Eduardo Paolozzi, 1965.
9. DURENMAL. By Eduardo Paolozzi, 1965.

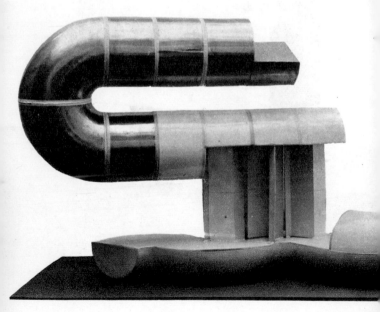

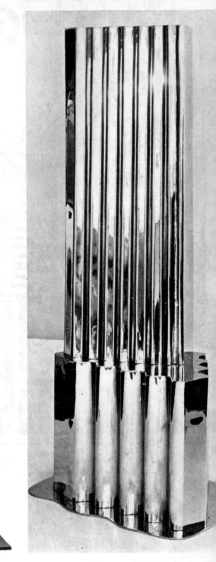

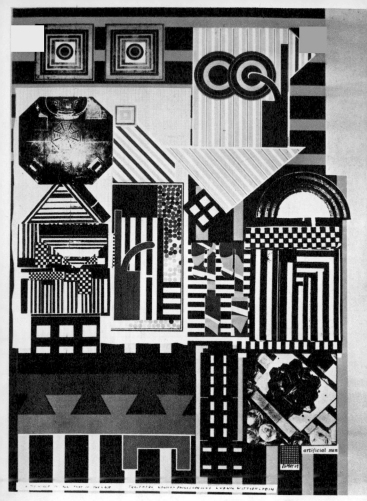

10. AS IS WHEN – ARTIFICIAL SUN. By Eduardo Paolozzi, 1965.

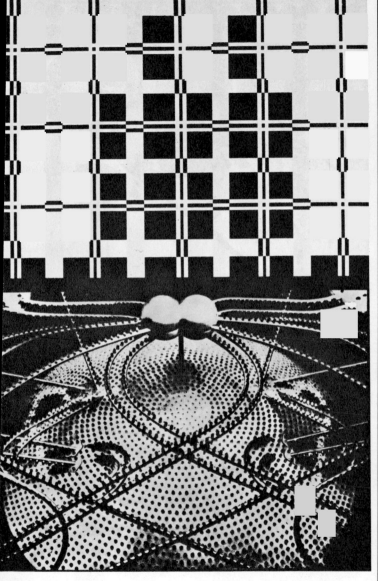

. From MOONSTRIPS EMPIRE NEWS. By Eduardo Paolozzi, 1967.

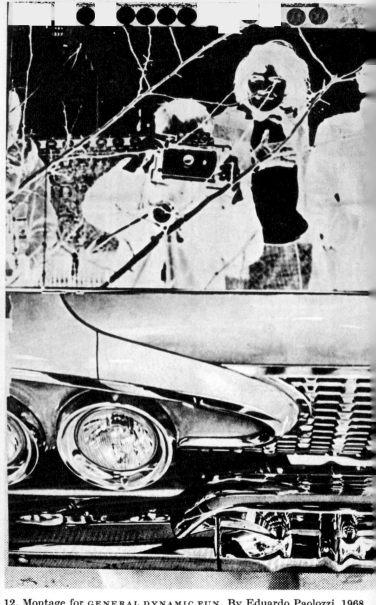

12. Montage for GENERAL DYNAMIC FUN. By Eduardo Paolozzi, 1968.

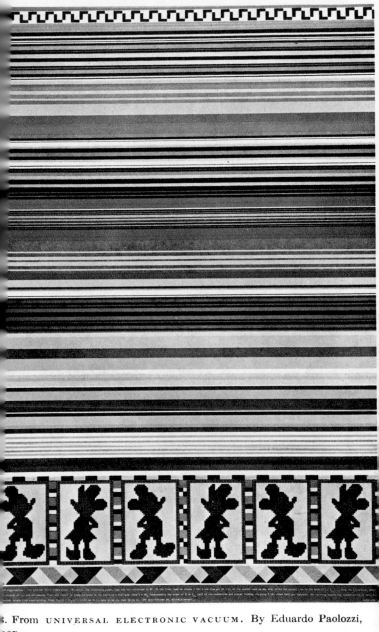

8. From UNIVERSAL ELECTRONIC VACUUM. By Eduardo Paolozzi, 1967.

14. REVLON. By Richard Smith, 1960.

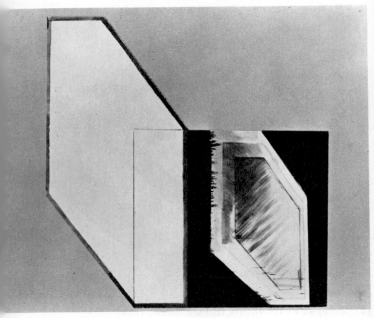

FLEETWOOD. By Richard Smith, 1963.

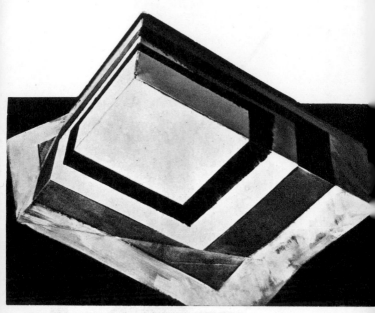

16. *(above)* SURFACING. By Richard Smith, 1963.
17. *(right)* RED CARPET. By Richard Smith, 1964.

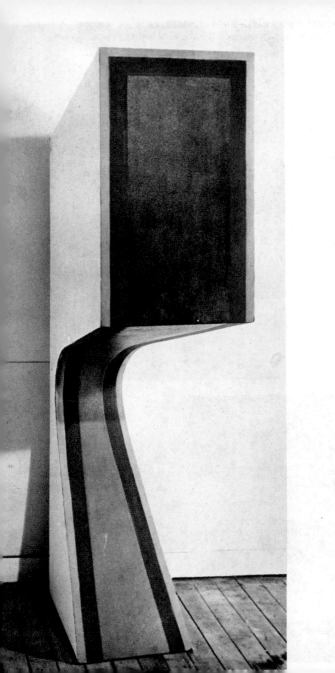

18. *(above)* GIFT WRAP. By Richard Smith, 1963.
19. *(below)* RING A LINGLING. By Richard Smith, 1966.

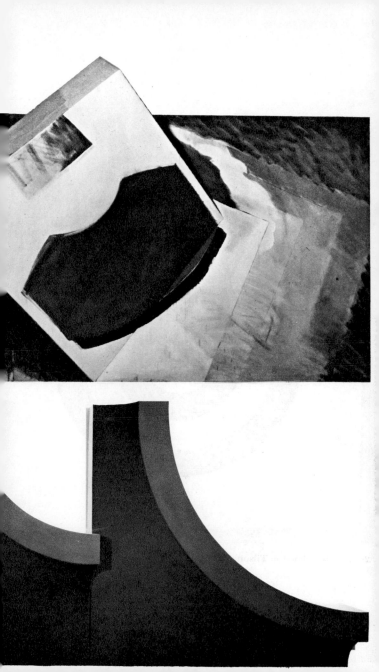

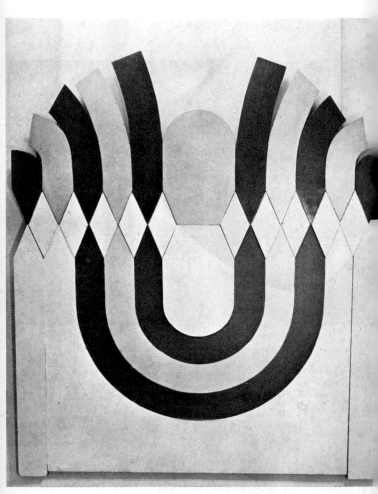

20. ODEON. By Joe Tilson, 1962.

. A–Z. A CONTRIBUTIVE PICTURE. By Joe Tilson, 1963.

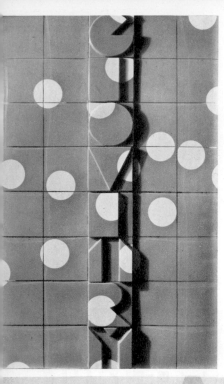

22. *(left)* 3D GEOMETRY
By Joe Tilson, 1965.
23. *(below)* ZIGGURAT I⟨
By Joe Tilson, 1965.

DIAPOSITIVE, EMPIRE STATE BUILDING. By Joe Tilson, 1967.

25. *(above)* EVERLY WALL. By Peter Blake, 1961.
26. *(right)* LE PETIT PORTEUR. By Peter Blake, 1964–5.

673·Le petit porteur.

27. PIN-UP GIRL. By Peter Blake, 1965.

FIVE. By Adrian Berg, 1965.

(left) SNAKES AND LADDERS. By Adrian Berg, 1966.
(above) EUROPE BY RAIL. By Adrian Berg, 1966.

31. TAROT VARIATIONS. By R. B. Kitaj, 1958.

CRACKS AND REFORMS AND BURSTS IN THE VIOLET AIR. By
R. Kitaj, 1962.

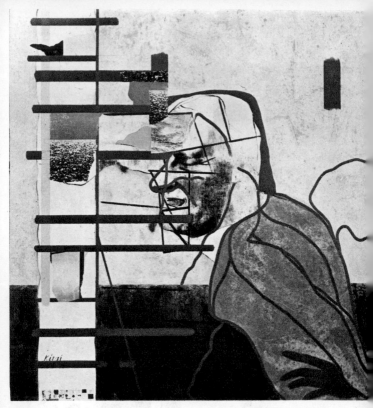

33. PORTRAIT OF NORMAN DOUGLAS. By R. B. Kitaj, 1963–4.

WHAT IS A COMPARISON? By R. B. Kitaj, 1965.

35. *(above)* MORT. By R. B. Kitaj, 1966.
36. *(right)* FOR MEN ONLY STARRING MM AND BB. By Peter Phillips,
1961.

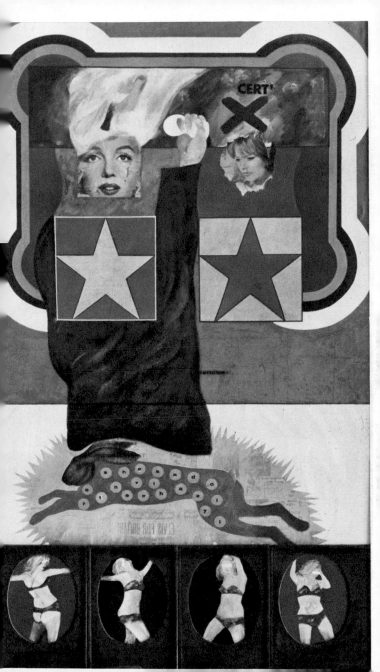

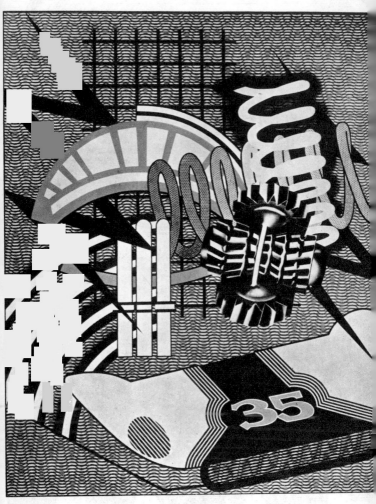

37. CUSTOM PAINTING NO. 4. By Peter Phillips, 1965.

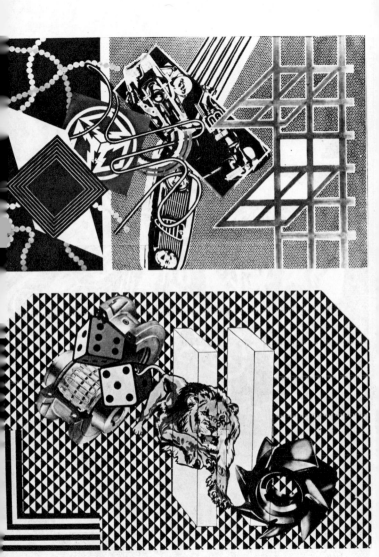

(above) CUSTOM PAINTING NO. 8. By Peter Phillips, 1965.
(below) THE LION NO. 2. By Peter Phillips, 1968.

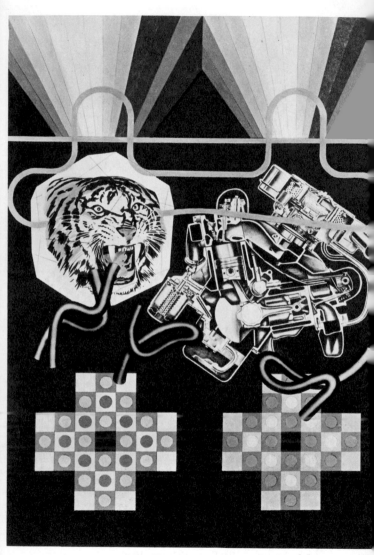

40. TARZANA. By Peter Phillips, 1968.

TIGER TIGER. By Peter Phillips, 1968.

42. NUMBER SIXTY-SEVEN. By Gerald Laing, 1965.

DECELERATION 1. By Gerald Laing, 1964.

44. *(above)* ORANGE SKYDIVER. By Gerald Laing, 1964.
45. *(right)* SLIDE. By Gerald Laing, 1965.

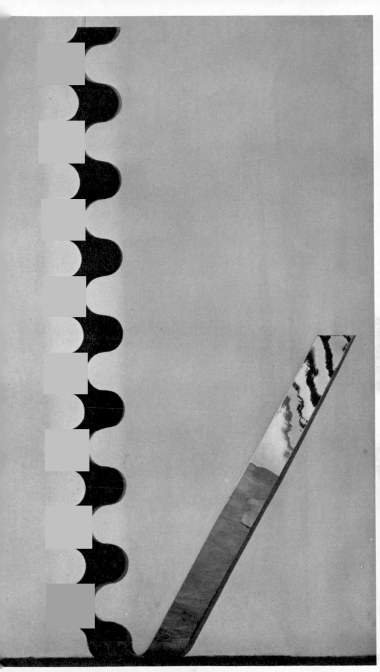

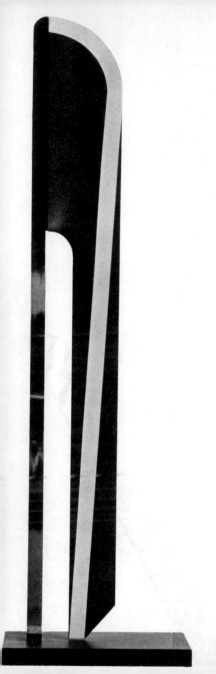

46. *(left)* PURPLE PIN.
By Gerald Laing, 1967.
47. *(above right)* THE BATTLE
OF HASTINGS. By Allen Jones
1961–2
48. *(below right)* 2ND BUS. By
Allen Jones, 1962.

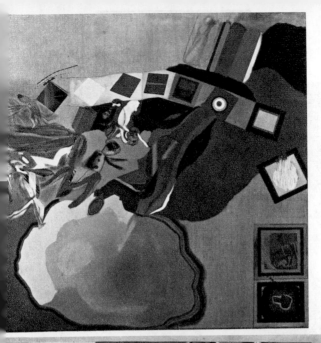

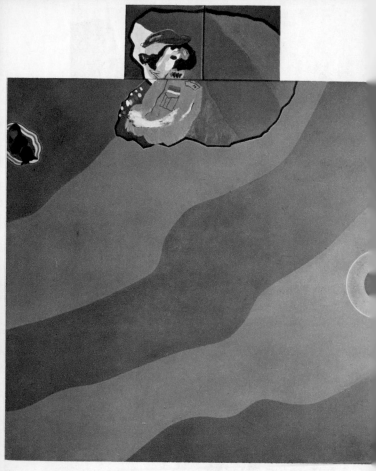

49. THE LONG DISTANCE FIGHTER. By Allen Jones, 1962.
50. *(above right)* ... DANCE WITH THE HEAD AND THE LEGS. By
Allen Jones, 1963.
51. GREEN DRESS. By Allen Jones, 1964.

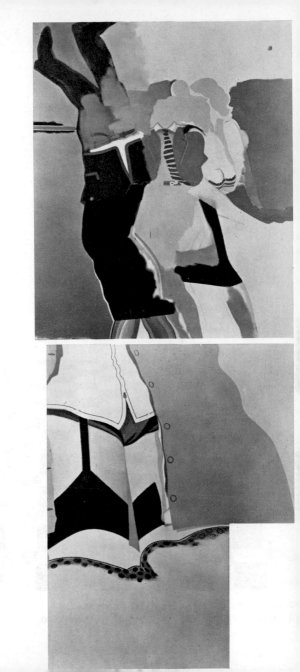

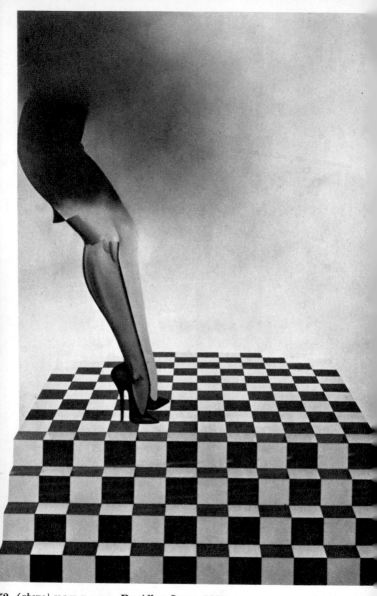

52. *(above)* YOU DARE. By Allen Jones, 1967.
53. *(right)* TYPHOO TEA. By David Hockney, 1960.

54. MARRIAGE OF STYLES I. By David Hockney, 1962.

A BIGGER SPLASH. By David Hockney, 1967.

56. A NEAT LAWN. By David Hockney, 1967.

RED, WHITE AND BLACK STILL LIFE. By Patrick Caulfield, 1966.

58. VIEW OF THE BAY. By Patrick Caulfield, 1964.

VIEW INSIDE THE CAVE. By Patrick Caulfield, 1966.

60. THE WELL. By Patrick Caulfield, 1966.

NEW YORK STREET AND WOMAN. By Colin Self, 1965.

62. SHE'S GOT EVERYTHING SHE NEEDS, SHE'S AN ARTIST, SHE
DON'T LOOK BACK – FALLOUT SHELTER 5. By Colin Self, 1965.

CINEMA SERIES (COINCIDENCE NO. 1). By Colin Self, 1965.

COLIN SELF HOT DOG 10.

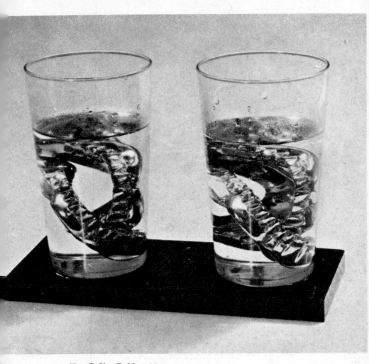

HOT DOG 10. By Colin Self, 1966.
(below left) BEACH GIRL, NUCLEAR VICTIM. By Colin Self, 1966.
(above) TOM BRUEN'S TEETH. By Clive Barker, 1966.

67. *(above)* STILL LIFE WITH DRAWING BOARD. By Clive Barker, 1966.

68. *(right)* SPLASH! By Clive Barker, 1967.

69. *(above)* NEWSPAPER. By Clive Barker, 1967.
70. *(right)* LINDNER DOLLY. By Jann Haworth, 1967.

71. DANCERS. By Nicholas Munro, 1966.

conscious effort (polished by habit) is required to read the image in terms of any possible experience of extended matter. It is easy to remain detached from newsprint and the daily paper tends to take on a rather formal character; the pattern of reading is apt to become more important than the events described.

Much the same could be said of Laing's work and quite rapidly the formal approach assumed dominance over the imagery. The helmeted head and spread arms of a sky-diver would be reduced, now, to being a pendant from large, serpentine areas of flat colour – nominally the silk skeins of a parachute but in fact assuming an existence independent of the external world. Sense-data had been synthetized into a two-dimensional structure – a record of a visual experience which becomes a visual experience in its own right. This could, of course, be said to describe, in a general way, all art of all periods – but with reference to the art of the present century it has a particular relevance. The concept of an art work being not merely descriptive or evocative but having an independent existence is a pri-mary feature of modern art. In his progress from recorded image to formal statement, Gerald Laing has pursued a classical course. What gives his work a special interest is that it has evolved from a point which had not been much considered before the present decade – the ephemeral, a-compositional, journalistic image.

Within the context of painting, then, Laing evolved towards the use of flat colour zones, formal structures and the shaped canvas. It was quite logical for him to move on to shaped metallic pieces – constructed from painted aluminium and chromed brass – which were, in effect,

I.L.–5

totally abstract (although traces of his earlier imagery can be detected).

At about the time of this change Laing collaborated with Peter Phillips, then also resident in New York, on the market research project *Hybrid*. As we have seen, art preferences, taken from a sample of informed laymen, were processed by a computer and an object was built to conform with the specifications it produced. The experiment had a considerable impact on both artists and it seems to me that in both cases an important aspect of this was the emphasis which it placed on the notion of method as subject. In *Hybrid* the entire concept of market research – and, more specifically, the process of research and analysis – became the subject. In the later work of both Laing and Phillips we find that the method of working takes on a particular significance. In the case of Laing, the techniques of shaping and construction in metal have reinforced formal qualities which were already present. He has been led to explore symmetry and asymmetry for their own sakes – as well as, for example, articulation of surfaces through the use of colour and reflective areas.

Laing's earliest metal pieces were sometimes freestanding, sometimes designed to be seen flush against a wall (Figure 45). In most cases they do not articulate space as does conventional sculpture, they do not function through interpenetration of an environment; neither are they specifically concerned with *Gestalt* in the way that the structures of Robert Morris, and some other minimalists, are. Rather they might be described as paintings conceived in terms of sculptural method. With few exceptions

Figure 46) there is a distinctive flatness about them.
Even when freestanding they seem to exist in terms of a
picture plane (and here we may detect a relationship with,
for example, Richard Smith's three-dimensional shaped
canvases).

It is probably this quality of Laing's pieces which seems
to demand an hermetic environment. In his more recent
work he has tended to create his own environment by
enclosing the structures in shallow formica boxes. This
recalls Poussin's instructions to one of his patrons, to the
effect that his paintings must be properly framed since the
frame should insulate the image from the world at large.
More significantly, though, we may be reminded once
more of the newspaper photograph which is effectively
insulated from reality by the columns of print that hem it
in. Even the caption of a photograph tends to distance it
from reality since the necessity for description emphasizes
the reliance which is placed upon conscious reconstruction
of the event portrayed. In the case of Laing's objects, the
titles operate in something like the same way, providing
a verbal insulation which distances the observer and there-
fore emphasizes the conceptual aspect of the work. None
the less, Laing's pieces have a strong physical presence and
the ambiguity between the direct retinal response this
demands and the sense of distance produces a subtle
balance of tensions. This emphasizes, perhaps, his back-
ground of figurative painting since it is much more
common for figurative paintings to work in this way (the
observer identifying with the subject yet feeling removed
from it).

Laing's progress has been quite logical and can be seen

as the resolution of the problems which he set himself in his earliest work. The initial consolidation has been made and we can expect him to use this as a platform for new explorations.

10 · Allen Jones

b. 1937

The currency of Allen Jones's art is ambiguity. Ambiguity here does not imply evasion; in Jones's paintings many different kinds of ambiguity are poised in a state of constant interplay, creating a complex of tensions. The tensions vary as the observer's perspective shifts (and the nature of ambiguity dictates that it must shift), but in such a way as to remain flexible without becoming lax and enervated.

In 1961/2 he painted a large canvas, *The Battle of Hastings* (Figure 47), which already displayed this quality of flexibility. In this composition freely painted figurative elements are juxtaposed with fluid fields of colour. An heraldic ribbon made up of gently misshapen diamonds, a target and patterned squares are strung across the surface of the painting. Broken lines, a tiny flag, printed words and two insets, which are virtually paintings in miniature, also contribute to the profusion of incident which spreads across the whole expanse of the picture plane. Space is suggested or delineated in several different ways, varying from implied illusionism to cartography. The total effect is reminiscent of those school maps dotted with illustrational panels except that here the figurative elements are totally fused with the composition. The interplay between

all these varied components is such as to make the painting
appear to be constantly re-creating itself.

The artist remarks that *The Battle of Hastings* is about
deep space; about the picture as a field to be activated.
Paint is used here primarily as a spatial marker and only
secondarily as a vehicle for imagery. Beyond this *The
Battle of Hastings* is a key painting in that it presents a
schematic outline of much that was to follow. The artist
considers that the configuration of elements within this
composition already displays the basic structural patterns
which are found throughout his work.

The General and his Girl, painted at about the same time,
displays – without being germinal in the same sense –
many of the same characteristics. The General's head is a
large, loosely drawn balloon (though it is interesting to
note that this balloon was almost the last addition made
to the composition) with slits for eyes in a face that is
otherwise composed of gestural brushstrokes which seem
to have drifted there from some abstract expressionist
canvas. The girl – playing Patience with the General's
medal ribbons – seems, by comparison, virtually illu-
sionistic yet she too is composed of apparently 'abstract'
elements, compartmentalized into several well delineated
zones (one of which contains a star map showing the Big
Dipper). It is also worth noting that three supplementary
canvases – plain squares of colour surrounded by contrast-
ing borders – are attached to the top of the main three
foot square canvas, an anticipation of a device which
Jones was later to exploit.

At this stage in his career Jones developed his pictures
from a single starting point – a particular image, maybe,

which had seized his imagination – with no clear notion of what the final result would be. His method of working was closely related to the surrealist idea of automatism; he was concerned with the paint mark as autobiographical statement. A touchstone throughout his career has been his own idiosyncratic notion of self-portraiture. The head itself (the first relevant example dates from the late fifties) is not treated as an icon but as a premise which must be destroyed in order to create a painting. In the 1961 canvas *The Artist Thinks* a fragmented head serves as the launching point for a series of automatic paint statements which are ultimately enclosed in a 'thinks' balloon. But, as in the case of the General's head, the balloon represents a final compositional decision and not a pre-planned plastic device. Jones differed, even then, from an abstract expressionist in that he did not place any *intrinsic* value in the autobiographical nature of the paint process. The picture surface remains loose until the painting gells into its final state. 'Only then is it brought into high focus (flat or saturated colour areas) and thus becomes real.' Jones further insists that the picture should be 'silent' – not betraying the history of its making, since its *idea* is not about its *making*. As, over the past five years, he has moved away from reliance upon automatism this quality of picture silence has become increasingly evident.

These early paintings were already mature examples of the language cluster technique, pioneered by Richard Hamilton in the fifties and arrived at independently by Jones and others a few years later. One can see at work in Jones's output of 1961/2 the influence of Delaunay, Kandinsky, the surrealists, abstract expressionism, Jasper

Johns; elements are taken from these different language systems and synthesized into a personal idiom. This process of synthesis is natural and organic yet at the same time quite conscious and controlled.

In 1961 Jones painted the first of his series of bus paintings. Here another of his recurring preoccupations – the shaped canvas – makes its appearance. The shaped canvas is not used by him as a gratuitous gesture; in this instance it is an integral part of his solution to the formal problem which he had set himself. He was concerned with the theme of a bus in motion (the idea originated in a class exercise which he had set his students). To achieve the effect he was after he struck on the idea of using a sloped parallelogram, sometimes a strict rhombus, sometimes not – but always leaning to the left. In Jones's treatment the image and the canvas are simultaneous; the canvas *is* the bus. Sometimes the wheels are appended on separate square canvases grouped together at the base of the main image. This tends to give the composition a necessary stability (Figure 48).

The coincidence of canvas and image highlights an aspect of Jones's work which has been generally misunderstood – the role of figuration in his work. There is a tendency to think of him as an abstractionist manqué who has used Pop imagery to pep up his canvases; or, alternatively, as a Pop artist with a highly developed decorative sense. Both of these estimates are very inadequate. It would be much nearer the truth to say that he is engaged with formal problems in much the same way as an abstract artist but has chosen to integrate the question of figuration with these formal problems. This does not necessarily

imply that Jones is unengaged with the subject matter –
that it is irrelevant in itself, or arbitrary. He clearly has a
keen eye for pre-existing imagery and is prepared to tap
these sources of visual exhilaration; but once they are
transferred to the canvas they become integrated with the
formal problems. I have said of the paintings under im-
mediate discussion that they were concerned with the
theme of a bus in motion. In a more profound sense they
were concerned with the relationship that exists between
the apparent motion of the subject and the optical motion
of the painted image. Jones's approach differs from that of
the Futurists who relied upon drawing and graphic illusion
to create a sensation of kinetic movement. He exploits
occidental habits in reading pictorial matter (it is with this
latter consideration in mind that the sloped parallelograms
lean to the left and never to the right).

This integration of figuration with formal problems
applies to the entirety of the artist's output but is especially
relevant where the image is simultaneous with the canvas.
So far as the Bus series is concerned several of the paintings
combine schematic figuration, colour fields, and quasi-
heraldic devices in a way that is a clear development from
earlier paintings but – once the coincidence of canvas and
image had been established – he was able to paint versions
which were abstract in all but this one sense (for example
Yellow Line Bus of 1963). Where the shape of the canvas
can imply the content of the painting the function of the
painted mark is radically challenged. The artist remarks
that marks which are meaningful on a rectangle can become
merely superfluous description when applied to a shaped
canvas. Awareness of this led Jones away from reliance

upon the 'autobiographical' methods of his earlier work.

Many of the concerns of the Bus paintings were carried over into two other series; Aeroplanes and Parachutes. By inverting the format of the Bus paintings – placing the two small canvasses at the top of the main canvas – he found that an aeroplane's cockpit was suggested (Figure 49). This provides an example of formal considerations leading to a particular choice of imagery. The Parachute paintings involved a completely new format – a long rectangular canvas suspended beneath a larger polygonal canvas. In *Gentle Descent* an hermaphroditic figure (partially disintegrated in the same way as the self-portraits – and for the same reason) occupies the smaller canvas. Above this figure a parachute blooms. I choose the word 'bloom' not just for effect but because this configuration of canvases can also be read as a flower in blossom; in other circumstances Jones had made use of it to represent head, neck and shirt front. Inverted it becomes a medal – a device that the artist later made good use of. Contemporary with the Aeroplanes and Parachutes, but not capitalizing upon the shaped canvas, is the large (8 ft × 9 ft) *Sunplane*. This is a quite straightforward image – a camouflaged aircraft flying over concentric rainbow circles – directly related to personal experience.

In the same year (1963) Jones developed the hermaphrodite theme. In paintings such as ... *Dance with the Head and the Legs* (Figure 50), male and female imagery is combined into a single organism. These hermaphroditic entities are by no means concerned with a strictly transvestite theme – this is not a painted equivalent for *Flaming*

Creatures. Rather they are a fresh enrichment of Jones's vocabulary of ambiguities. Their source is the Nietzschean notion that the creative function involves a specific balance between male and female attributes. *Dance with the Head and the Legs* is a quotation from *Zarathustra*; the composition is an archetypical example of Jones's use of ambiguity. The illusionism of the breasts does not seem to belong to the same language system as the colour fields that surround them and this shift of idiom is repeated half-a-dozen times across the canvas. But these shifts and stylistic ambiguities are all carefully balanced against one another, the feedback between them sustaining the canvas in a constant state of equilibrium (all this underpinned by the sexual ambiguities). The picture plane is exploited ruthlessly but allowed to retain its integrity.

Eroticism has been a recurring element in Jones's work, dating back at least as far as *Bikini Baby* which he painted in 1962. The hermaphrodite canvases were followed by others which were more direct in their eroticism – direct in so far as the imagery was presented in a quite straightforward and graphic way. In compositions such as *Green Dress* (Figure 51) the subject matter is quite unequivocally legs, stocking-tops, suspenders – the imagery is as legible as in a drawing by Vargas (whom Jones greatly admires); as legible but less complete, since Jones rarely presents the whole figure. In fact he deliberately avoids the vignette image since – even when dealing with this very direct figuration – he is primarily concerned with relating plastic elements to the four edges of the canvas. The immediacy of the imagery draws the observer into

contact with the formal considerations of the composition. Eroticism is used here not as an end in itself but as a psychological magnet.

Jones is not a one track artist, however, and the same year (1964) saw him exploring alternative solutions to the same formal problems. A development of the self-portraiture theme was his quest for a formal device which would read as head and features and we find him returning to the same misshapen diamond that he had first employed in *The Battle of Hastings*. The diamond now occupies the whole canvas and features are arranged on it with an obsessive near-symmetry which brings to mind a Jungian mandala. In other paintings, such as *Falling Figure*, this head is used in conjunction with the hermaphrodite theme to explore once again the relationship between the apparent motion of a subject and the optical motion of the painted image.

In 1965 Jones turned his attention to three-dimensional free-standing images. In most cases these were serpentine wooden columns topped with wooden or plexiglass cut-out shapes; but one of the most interesting examples is a plexiglass column transformed, with the aid of a length of rope and a painted skirt, into a hermaphroditic figure. The skirt is painted onto a square of plexiglass set at a shallow angle from the horizontal at the waist of the column. Above the skirt the rope curves down inside the column to form the figure's spine, then it emerges beneath the skirt as a semi erect penis (the direct inspiration for this image was a Hellenistic bronze which the artist discovered in a study of eroticism compiled by Lo Duca). The front of the column is smeared with two patches of paint. From

a short distance all these opaque elements appear to be floating in mid-air.

Towards the end of 1965 Jones began work on a painting entitled *My Battle of Hastings Five Years Later* which re-explored the territory of the earlier canvas but in terms of his later development. All superfluous gestures have been eliminated from this second version. The artist was now conscious of the means available to him and the scene was set for the paintings that have occupied him until the present date.

The imagery of Jones's recent work is once again erotic, the predominant motif being a pair of legs – feet thrust into fetishistic high-heeled shoes. At the base of the canvas (the shoes rest upon the base) is a narrow ledge or, in other instances, a short flight of steps leading down to the floor. These steps are tiled in a checkered pattern and this pattern is continued on to the picture plane as an illusory floor painted in strict perspective. As the observer alters his position, shifts in the real perspective of the steps and the perspective represented upon the picture surface are at variance with each other. The illusory space within the painting bands as though refracted through a prism. But this is not the only spatial ambiguity involved. It is generally the case that one leg is modelled with the obsessive all-over quality that can be found in fetishistic illustrations while the other is portrayed quite flatly as a stylized silhouette. The observer's efforts to reconcile this disparate representation result in further spatial distortions. The fact that the shoes rest on the base of the canvas implies that it has a weight-bearing function. This is borne out by the presence of the ledge/steps device; but in one

painting the figure is also leaning against the ledge of the canvas thus demanding of the observer yet another retinal adjustment. The imagery, of course, has an impact quality (very rare in British art) which *forces* these adjustments upon the observer – there is no question of coming to terms with them at one's leisure (Figure 52).

Jones's development as a painter has been paralleled by his prolific print-making activity and he must rank amongst the best exponents of lithography working today. As a painter he has possessed from the outset of his career an outstanding fluency. It is to his great credit that he has not allowed this fluency to dictate his development. Instead he has applied considerable mental effort to exploring the formal implications of his work and has moved – and is moving – towards a capital statement which holds, in potential, a radical solution to the crisis which surrounds the gap between the world as we see it and the concrete reality of the painted image.

11 · David Hockney

b. 1937

David Hockney's paintings and prints can fairly be described as being camp. They are camp in the sense that Opera Bouffant or *The Eccentricities of Cardinal Pirelli* can be said to be camp.

Hockney has said 'I think that my pictures divide into two distinct groups. One group being the pictures that started from, and are about, some "technical" device (i.e. curtain pictures) and the other group being really dramas, usually with two figures. Occasionally these groups overlap in one picture.' I think it is important that he says 'are about' some technical device since this exactly describes his method. He does not merely use or exploit technical devices; he makes pictures which 'are about' technical devices. This is a key aspect of the campness to be found in Hockney's paintings and prints. He is making witty, often intelligent and always detached use of devices with which other artists are, or have been, deeply engaged. This humorous detachment is Hockney's strength and, at the same time, it defines his limitations. I think it is inconceivable that he could ever become a direct influence on the mainstream of painting since this detachment precludes the possibility of his ever becoming obsessively involved

with the formal questions that are the core of serious art activity. Many major artists are detached from some particular – their subject matter, say – but this detachment seldom extends to the exploitation of technical devices on which (for them) too much depends.

One of Hockney's earliest successes was the 1960 canvas *Typhoo Tea: Painting in the Illusionist Style* (Figure 53). Another painting was in the *Semi-Egyptian Style*. This ironic exploitation of style is comparable, on one level, with Patrick Caulfield's early work but Caulfield always pushed beyond irony towards a concrete, integrated composition. Hockney depended more on surface effects. His facility with paint (and with the etcher's needle) enabled him to pull off *tours de force* of style manipulation which, in other hands, might have seemed merely facetious. It is this kind of casual or apparently casual – virtuosity which is essential to the conscious exploitation of camp (Figure 54).

Those paintings which Hockney describes as being concerned with dramatic situations are, it seems to me, also inevitably concerned with technical devices. When presenting two figures together, the environment Hockney provides for them usually – and this is especially the case in his earlier work – has the character of a stage set. In some cases, *The Hypnotist* for instance, the setting is quite specifically a stage. He means the word 'drama', it would seem, in both senses and the representation of a dramatic situation on canvas, in two dimensions, automatically brings a range of technical devices into play.

Behind Hockney's witty – almost flippant – manipula-

tion of style there is to be found, curiously perhaps, a strain of social comment. His version of *The Rake's Progress* is a suite of etchings begun in London but completed in New York and dealing in a branch of satire that possibly derived from Hogarth but became, in essence, all Hockney. Harlem, the Bowery, Madison Square Gardens – all these were subjected to his alchemy of transformation. In these prints – and in some paintings of the same period – there is no escaping the satirical content (a row of humanoids, for example, marches backwards to music provided by their own transistor radios). In Hockney's more recent work this overt social comment has been conspicuously absent. It can be argued that it is still there, but dormant.

A number of paintings have been concerned, in a very direct and matter of fact way, with Los Angeles subject matter – swimming pools, for instance, and sprinklers playing on lawns which stretch like viridescent bibs in front of suburban villas (Figures 55 and 56). It may be thought that these compositions are a comment sharing the popular moralists' obsession with 'the emptiness and vapidity' of the Californian way of life; but, since Hockney makes no secret of his liking for California, this seems improbable. What remains, in the best of these canvases, is the same sensitivity to social phenomena that marked the earlier and explicitly satirical compositions. The fact that he is not using this sensitivity as a tool of criticism does not mean that it is blunted. It is arguable, though, that his acceptance of the Californian environment does preclude the free play of wit which was such a vital element in his early work.

Hockney seems to be faced with a problem of accep-
tance. Since he feels at home in California and responds to
it as a visual environment he is unable to bring into play
the witty manipulation of idiom which characterized his
early work. The idyllic bizarreness of Los Angeles is an
almost exact equivalent for his native idiom – matches his
own flair for a combination of hedonism and stylistic
perversity. His brand of irony becomes unnecessary in
California since it is implicit in the inhabitants, the
gardens, the architecture.

This discovery of a landscape which matches his taste
has led him to adopt a new approach which might be
loosely described as a form of naturalism. Like Peter
Blake, Hockney now humanizes subjects which are usually
subjected to the most dehumanizing of treatment. Los
Angeles is commonly portrayed as a plastic environment
composed of undifferentiated clichés. It is these descrip-
tions which can properly be called synthetic and cliché-
ridden. Hockney's new role may be to help disperse these
clichés and to assign human values to a culture which is
perhaps no worse than any other.

This directness is not limited to Los Angeles subjects.
It is typified by the series of etchings he did illustrating
poems by the Greek-Alexandrian poet Cavafy. These were
published in book form in 1967, with translations of the
poems by Nikos Stangos and Stephen Spender. Hockney
has chosen those of Cavafy's poems which are concerned
with love in a twentieth-century and predominantly urban
setting (pre-Nasser Alexandria was not perhaps too far
removed in mood from Los Angeles). The poems are
precisely written but vernacular in tone. Rhetoric is alien

to them and this is reflected in Hockney's etchings. Like
the poems they are matter of fact yet precise. They rely
for their impact upon a skilful manipulation of line in
which discipline is masked in apparent ease.

12 · Patrick Caulfield

b. 1936

Of all the painters discussed in this book, Patrick Caulfield is the most specifically European. He has learned from the Americans but remains firmly within the European tradition. It is true – though not the whole truth – to say that the subject of his paintings *is* the European tradition. For him the greatest benefit of contact with the new American painting has been that it has given him a more objective view of European art.

In 1961 he exhibited four highly personal pictures in which figurative devices – cut-out mountains copied from the labels of date packets, a naked sun-bather – were juxtaposed with purely decorative elements. These decorative elements were predominantly coloured grids; simplified versions of Scottish tartans. He was intrigued by the possibility of incorporating into these extremely sophisticated compositions the symbol of something so primitive as the concept of clan.

The irony was then too buried to be easily perceived but it has been a recurring factor in his work. These early paintings were remarkable for their originality rather than for their actual achievement but, in this irony and in this use of the decorative, they contained the seeds of much that was to come.

The next stage was for the grid to become a painted wooden trellis to which pastel-coloured figures and petals – cut out from hardboard – were attached. The results were interesting but the technique contained certain built-in limitations and he soon abandoned it to embark upon a series of paintings in which, once more, there was a juxta-posing of figurative and decorative; but this time the figurative elements were much bolder – a gigantic engage-ment ring, a flight of doves looking like fugitives from some sardonic alliance between Picasso and Vernon Ward – and the decorative elements appeared to derive directly from Synthetic Cubism. Sometimes the figurative devices too looked as though they had been transplanted from a Gris or Léger still-life, but at the same time the paintings (which were often executed in stark black and white, without the relief of colour or tonal gradation) had an atmosphere which was quite different from anything that is to be found in Cubism.

At this time Caulfield was very much preoccupied with the idea of creating a formal plastic language, a contemporary equivalent of the classicism that sustained Egyptian or Chinese art (Figure 57). He is not, of course, the first modern painter to have envisaged such a language. Seurat – with his 'scientific' borrowings from Chevreul and Charles Henry – attempted to do something of this sort; but, whereas Seurat's language was at root one of line and colour (it might be called modal; he was fond of the musical parallel), Caulfield drew upon a reservoir of established imagery and stylistic concepts. From these ingredients he constructed his own idiom. His work shocks

the aesthetically squeamish in much the same way as did
Manet's (we have only to recall the *Olympia* and the cries
of 'Profane!' that greeted its transformed echoes of
Titian and Giorgione). Caulfield's approach to the
European tradition has a good deal in common with
Manet's.

Much has been made of Caulfield's use of the visual
cliché. It is true he has remarked that clichés must con-
tain a wealth of interest, otherwise they would not have
become clichés in the first place; and he has endeavoured
to release the frozen energy that they hold, just as Billie
Holliday squeezed poetry from the hackneyed lyrics of
popular songs. That said, it should be noted that his
vocabulary, grammar and syntax derive at least equally
from the fine arts. Critics who have presented him as
merely the saviour of the cliché have done him a gross
injustice by ignoring the range of his work.

Like Seurat, Caulfield could see no reason why a fixed
visual language should be any more constricting to the
painter than French or English is to the writer. He did not,
it goes without saying, imagine that he could impose such
a language on the whole art world; what is important is the
effect that this kind of thinking has had upon his own
work. The language that he employs can be readily under-
stood by anyone with a knowledge of the historical idioms
of art. The greater your fluency in these idioms, the more
you will be able to derive from Caulfield's paintings. With
these chosen and fixed terms he is able to create paintings
which are personal to an extent that makes the mammoth
signatures of most abstract expressionists appear drably
uniform.

Allied to this concern with the language of painting was his
interest in the idea of decorative art which, he felt, had
fallen unjustly into disrepute. To understand what
Caulfield means by decorative art we must go back to a
painter like Uccello and a painting like the Louvre *Battle
of San Romano* with its shallow space, the pattern of
brightly hosed legs beneath the bellies of the horses, the
array of lances against the dense background. This is
undeniably decorative art but that does not stop it from
being a good deal else as well.

In the 1964 New Generation show at the Whitechapel
Art Gallery – it was at this exhibition that his work first
attracted wide attention – Caulfield exhibited a painting
titled *Still Life with Necklace*. This was an arrangement of
turkish pots, jewelled knives, a necklace; all of these
pulled together by formal geometrical devices. It was a
decorative painting but, like the Uccello, it was something
more – though, inevitably, what raised it above *mere*
decoration was quite other than that which performed the
same feat for the Florentine master.

To understand just what it is that raised a painting like
this still life above the level of mere decoration we must
recall that hoary notion which has propped up modern
painting for more than half a century – the idea that the
painting is a self-contained entity, existing as a thing in
its own right; that it is autonomous. This autonomy has
become, in recent years, merely academic – the tritest of
art-school formulas – but it is by a witty manipulation of
this concept that Caulfield has been able to achieve his
results.

In Seurat's observation that he thought of the frame as

insulating the picture from the world at large we car
perhaps see the beginnings of the cult of pictorial auto-
nomy. Seurat made a valid difference between representa-
tion and that which is represented; he opened up a
humorous gap between what took place on his canvas and
what actually could be seen on a fine Sunday afternoon on
the Ile de la Grande Jatte (or rather – as Seurat himself
would have insisted – it was his method, his language,
that opened up the gap). With the new century young
painters took up the idea and expanded it into a justifica-
tion of their own non-illusory techniques. If the painting
is an object in its own right why should it be parasitic
upon other objects? Non-figurative painting was born of
these notions.

One danger is implicit in any exploitation of pictorial
autonomy; the painter who accepts this concept blindly is
liable to find himself swallowed whole by Style with a
capital S. A painter's style is something which – whether it
is the record of a set of nervous tics or the carefully
thought out presentation of an elaborate scheme – be-
comes manifest only on the actual canvas. It is the most
easily imitated feature of a great artist's work, because the
most superficial, and when the painting is seen exclusively
as a thing in itself – excused from all but the most casual
contact with the world at large – there is a very real
possibility that style may become everything; the painting
may be sucked dry by the most ephemeral of its consti-
tuents.

Style and fashion are not necessarily synonymous; they
can, however, easily become so. Looking back over the
history of art we can see how rapidly styles change and a

painting that is *merely* stylish can have only historical interest when the mode has been abandoned. If there is any truth to the accusations that art has become a sequence of fashions, the preoccupation with style is probably at the root of it.

Few painters have exploited the notions of style and the autonomy of the painting more ruthlessly than Caulfield, yet, in his best paintings, he avoids the dangers that I have outlined by re-establishing contact with the mainstream of the European imagination.

What he has done has demanded considerable poise. The fact that he has dared to play with the dangerous idea of decorative art has allowed him to use figuration in a near academic way without becoming even remotely academic. He has been able to steer his painting – especially in his more recent work – close to common-sense realism without abandoning the gains of the past sixty years. Because the painting remains autonomous there is a gap between what is represented and the representation; an ironic gap such as Seurat first opened up. But whereas Seurat was taking a first step away from the old concept of naturalism (though presenting the step as a scientific *extension* of the naturalist techniques) Caulfield is making the equally bold and necessary move of putting the new art – now fully mature – back in touch with the world of sense data and extended matter.

Or, rather, not quite in touch. The ironic gap remains. There is no question of breaking down the barriers between art and life such as seems to be envisaged by some American painters. A Caulfield Happening would be an unlikely event; the conventions of the puppet show or the Com-

media del Arte are nearer to his taste. His work is more
closely related to Racine than to the Theatre of Cruelty. It
is worth repeating that his is an essentially European
solution to the problem – European in a very traditional
sense.

Caulfield's approach to painting is rich in potential. One
thing that he has already done is to employ his irony as a
form of art criticism. If a painting is an object in its own
right it can be treated in just the same way as a turkish
vase or an engagement ring. Thus he has painted what are
really pictures of cubist paintings; critics who have seen
in these just a clever re-hash of what happened fifty years
ago have entirely missed the point. If he paints studio
composition he is not simply perpetuating a tradition but
commenting on it at the same time.

There is a story by the French humorist Alphonse Allais
about an artist who paints a water-colour sea-scape using
sea-water. The sea-water remains subject to the influence
of the moon and the tide in the painting rises and falls,
covering and uncovering the rocks. He gives the painting
to his fiancée. One night there is a Spring tide, lashed by a
fierce gale, and the girl is drowned. Caulfield's art is the
extreme opposite of this. In one painting (Figure 58) a
string of grey bunting is suspended across the intensely
blue water of a mediterranean harbour on which bob small,
brightly coloured boats. The sea in this painting is not
affected by the moon or any other agency; it has the static
beauty of lacquer on a chinese cabinet.

At the same time there is a sly linguistic echo – though
Caulfield's art could scarcely be further removed in aims

nd values – of Dufy and facile post-impressionist calli-
raphy. The buildings that line the port are indicated
chematically by an open grid of lines; reflections by a few
trokes of colour. The artist relies upon the spectator's
knowledge of the plastic shorthand employed by innumer-
ble tourist-orientated painters from Capri to Marbella; a
constant tension can be felt between the cool, deliberate
object that the painting is and the sketchy, atmospheric
mpression that it recalls.

It is this ability to pull something static out of the flux,
at the same time – through a witty manipulation of the
language of painting – not disturbing the sense of vitality
in the subject represented, that marks Caulfield's work.
The painting in question is indicative of a trend towards
the informal which has become noticeable in his later
painting; the fact that he no longer relies upon geometrical
devices to pull his paintings together has brought a new
subtlety to this tension between flux and static image
(Figures 59 and 60).

For all its poise and clarity of diction, Caulfield's work is
coloured by a strong romantic streak; this seldom, if ever,
makes itself felt in execution but appears in the subject
matter where it can be more easily dealt with (he has
painted, for example, a version of Delacroix's *Greece
Expiring in the Ruins of Missolonghi*).

One of his most typical paintings – and this allies his
romantic leanings to his war against the flux – is of ruins:
a few grey, crumbling walls and fallen stones set in a
landscape of which the only distinguishable features are
clumps of cactus-like leaves. Whereas the nineteenth-

century painter would have set out to project the pic
turesque decay into his picture and the twentieth-centur
artist – to date – would simply have ignored the subject
Caulfield arrests the decay and turns the ruins into some
thing complete and monumental. At the same time h
makes a humorous comment on his own romanticism.

If we can see beyond the visual clichés and the uncom
promising formalities of his draughtsmanship, we shall b
able to recognize in Caulfield a notable representative of a
familiar European tradition – the romantic disarmed by
his own irony.

13 · Colin Self

b. 1941

Colin Self is a draughtsman and sculptor operating quite
outside the style snobberies which often become the
politics of modern art. He does not need to advertise his
modernism by resorting to cliché modernistic devices. His
exploitation of the stylistic conventions of contemporary
art is minimal, but his acceptance of subjective and psycho-
logical insights is totally modern.

His method might be described as selective naturalism,
though this is to oversimplify. He talks of selecting events
and objects which are in themselves natural but which,
when put or forced together, react in such a way as to
produce results which are not quite natural. Slight but
effective distortions of individual images are also employed
to heighten the naturalism.

A New York street is drawn in immaculate perspective –
like an architect's rendition (Figure 61). In the street are
two cars, drawn with the same anonymous elegance but,
while the skyscrapers are evoked with line only, these
cars are conceived in terms of tone and mass; the chrome
work becomes a brilliant pattern of highlights and reflec-
tions. In the foreground is the head and shoulders of a
woman – rather grotesque with piled hair, the skin on her
neck folding into deep creases. Since the vanishing point

of the perspective corresponds in elevation with the fenders of the cars she seems to be situated below road level, yet otherwise her position in the picture suggests that she is crossing the roadway. Such an impression might be achieved with a telephoto lens, if we assume the gradient to be descending towards her, but no explanation of this kind is indicated by the artist so the effect is simply disturbing (the more so for being undetectable on casual inspection). Also the picture is curiously empty. Do these hundreds of windows overlook just two cars and a single pedestrian? The composition can be read as straightforwardly as a newspaper photograph but the selection of detail translates it into a sinisterly beautiful subjective image. This image is complete in itself – no stylistic fragmentation is employed – yet it implies a fragmentation of reality; it can be read as a snap-shot of a continuum, but no law of cause and effect is evident. It exists as a fragment of reality detached from any necessity of past and future. This implied fragmentation differs from stylistic and syntactical fragmentation in the way that a book like Terry Southern's *Flash and Filigree* differs from William Burrough's *Nova Express*. These novels illustrate two equally valid techniques – fragmentation of narrative flow and fragmentation of language. With Self's drawings, another literary parallel suggests itself; that of the science fiction writer who generally finds himself describing a non-Aristotelian situation from an Aristotelian viewpoint.

The drawing that I have been discussing, because of the apparent innocence of the subject matter, illustrates Self's visual techniques in a particularly clear way. Although it was not taken directly from nature it was begun in New

York while the artist was tuned in to the atmosphere of
the city, its sinister elegance charged by certain insights.
Self is greatly concerned with the way people adjust to
new environments and situations and with how the new
culture incorporates crisis into its behaviour patterns:

Cars (and other manufactured products) of a nation reveal many
of the characteristics of that nation. Because people have
adjusted to pessimistic events, leisure seems to have forced the
upper hand at the moment. Reflected to me in 'classic lines'
and bright new colours of many new cars, etc. Most people
appear to have forced fear of warfare from their everyday
existence by developing a greed for these comforts. Again this
is happening in a more extreme way in the U.S. and can be
seen more easily there.

This was written in 1965. In the drawing these insights are
sublimated by the objectivity of the technique but
become, in consequence, all the more potent. If handled
clumsily they might have seemed banal; treated with this
degree of technical detachment they become fused with
our perception of reality and take on an ominous validity.

It will be seen from the above statement that Self is
deeply concerned with the paradoxes of terror and pleasure.
In another drawing – a cinema interior – the screen is
occupied by three heavies engaged in the aftermath of an
act of violence while, in the auditorium, we see two young
women totally detached from this event, presumably
enjoying an evening out. Mishandled this might have
become a parable but Self's objectivity and selectivity
elevate it to quite another level of experience.

Self speaks of his interests and inverted interests:

In weapons, warfare, broken laws and other causes of degenera-
tion; entertainments, acts and escapisms which people then
seemed forced to invent to counteract the former. An example
is the development and installation of H. Bomber, missile
bases in the last decade. Intense fear – knife edge living of the
fifties. During this same period T.V. was popularized. A more
perfect tranquilizer couldn't have been invented. A hypnotic
kind of brain masturbator (sometimes backfiring, spouting
nuclear news).

When Self portrays the paraphernalia of nuclear strategy
– bombers, interceptors, guard-dogs snarling outside mis-
sile installations – he is not indulging in naïve propaganda.
He is presenting one side of the balance of terror and
pleasure which, he suggests, defines the character of our
age. This balance (or paradox) is crystallized in his series
of fall-out shelter drawings (Figure 62): a stripper lurches
forward into a simian pose, breasts drawn floorwards by
their own mass and the twin vortices of diamanté studded
nipples; a grotesque middle-aged nude enjoys the synthetic
ecstasy of a mechanical slimming belt; a girl with pheno-
menal hair and eye-lashes pulls a tumescent hot-dog
towards her open mouth while more sausages turn on the
spokes of an elegant grill. As a background to all these
leisure activities appears the leitmotif of the fall-out
shelter sign. The paradox is established. No overt moral is
drawn but the fact is stated.

Such direct statements are rare in modern art and Self
intensifies them through his sharp awareness of the sub-
liminal meaning contained by the objects that he portrays.
He was originally concerned with the appearance of objects
in the conventional academic sense – light, shade, colour

and the apparent weights of image caused by these things –
but began to feel that this was only half the battle, that it
was pointless to work with source material that was
initially weak. He became aware that subject matter can
have its own potency. He became fascinated by the way
that things which are suppressed in social life make dis-
guised appearances in the objects created by the same
society. He is interested, for example, in the conscious
exploitation of disguised eroticism that is found in
advertising art but he is still more interested by uncon-
scious or half-conscious parallels of this phenomenon; the
totally anonymous eroticism of machine parts and con-
sumer durables, of furniture and architecture. He has
made explicit drawings of cinema interiors and Chester-
field settees which sum up whole behaviour patterns
(Figure 63). They retain their anonymity but he charges
them with a new authority (his interest in automobile
design has already been mentioned).

At the same time he is capable of drawings which derive
their strength from sheer plastic skill: flower compositions,
for instance, made from petal pressings and glitter, which
have qualities close to those of Chinese brush drawings.
He expresses an interest in Oriental art forms (moon-
gazing parties, etc.) – in their validity and in their rela-
tionship with Western art.

At school Self studied technical drawing and metalwork
as well as the usual academic subjects. Many of his current
ideas about art originated at that time, before he had
received any formal art education. Later he attended
Norwich Art School and then gained a scholarship to the
Slade. He was worried by school closing early, not enough

working space, *no* private space; by the fact that art was
turned into a community activity (which he feels runs
against the grain for many painters). The staff he found
often unsympathetic to his outlook, though he singles out
the painter Michael Andrews as one teacher who gave him
vital encouragement. Important too was that the Slade
brought him to London where he met David Hockney and
Peter Blake who bought his work and convinced him that
it was possible to work outside the system. Also significant
were two extended visits to North America (U.S.A.,
Canada, Mexico) in 1962 and 1965.

Self remarks:

'Beautiful technique' (as it had been called) of my drawing is,
I think, near to sarcasm. It is meant to be overloving to the
point of becoming vulgar. Like a still sexually receptive widow
caring for her pet dog. Like going to a hunt ball and speaking
their accent in order to ridicule. What happened with the
drawings though was like having other guests turn, saying,
'He speaks so well, so beautifully.'

I feel effective drawing subjects that, say, depress or give me
a lot to think about, in a way which looks overloving, requires
terrific devotion, pressure and length of time to execute – with
subjects (sometimes) that look as if they're not worth it.

Drawing to me is an art. Also skating, fishing – and putting
the fish into a glass case for immortality.

Anyway, it's all like closing your eyes and trying to pin the
tail on a donkey.

I see no importance in 'end of the cul de sac' extremism of
belief with which much of the present day art scene is con-
cerned.

If one's work can 'only be understood by four people' etc.,
it might as well not be there.

He accepts, though, that the element of sarcasm can diminish and that he might already be absorbed with that technical beauty in a new way. In his sculpture this kind of sarcasm is less in evidence. He had studied painting but found it difficult to make a mark without feeling it belonged to someone else – so he made the break; it was, he says, exciting not to know anything about sculpture and sculptors.

His first sculptures were of aeroplanes – hybrids built up from American customized car designs – and in general his sculpture has been concerned with much the same themes as his drawings: a cinema interior; a Victor bomber surging upwards above banks of black missiles; hot-dogs. He has said 'To me a hot-dog is as important a twentieth-century development as (say) a rocket. Both reflect a stage reached, are products of our condition' (Figure 64). Again he remarks 'I enjoy the way museums present people. Antique trivia on velvet backgrounds, broken fragments of pots displayed and guarded. Most important thing (the people) being missing. In time our records become us. The hot-dogs were created incorporating that "museum" vision. Ephemeral.'

Two more recent pieces are concerned with terror themes. One – a female victim of a nuclear attack (Figure 65) – could scarcely be more direct. The limbs of the black naked body are mutilated; the tissues dissolving into an efflorescence of glistening crystals. The head and one breast are virtually untouched and their naturalism (the face is, ironically, a life-mask) prevents the spectator from escaping into aesthetic quarantine. This naturalism gives the piece that directness which distinguishes it from the

sculpture of the fifties – the cold war, humanoid distortions in jagged bronze that were called, in England, 'The Geometry of Fear'. This corpse has a visual fascination which prevents it from being taken simply as a gesture of protest, a moral icon. It becomes a surreal object implying a wholly surreal climate; a plastic equivalent for the Theatre of Cruelty; a cataclysmic heir to Egyptian funeral art.

The other is a diorama representation of one of Self's central themes – a dog guarding a missile installation. Inside a large, tumescent cabinet (from the back it looks something like a barrage-balloon or a magnified detail of the upholstery of a 1940s Cadillac) a stuffed guard dog snarls amongst barbed wire and perimeter vegetation. Formalized missiles rear at the base of the cabinet. The whole panorama is sprayed black (the dog's eyes glow yellow in this pitch landscape) and is illuminated by white and red spotlights. Here, rather than crystallizing the situation into a single object, he presents us with a bizarre segment of this surreal zone. The total effect is one of claustrophobia. Apart from the overt subject matter this piece is concerned with the subjective experience of confined space – the everyday experience of the city-dweller.

In the climate of evasion that exists today Colin Self's work is not easy to take. He says, 'Art to me is a parasite. All the greatest art is firmly attached to and reflective of the great religions, political or scientific developments (or the mis-employment of these developments). Like the parasite sucker fish beneath the shark; it must travel with the shark in order to exist.'

If we accept his paradox of terror and pleasure then

where do we place art? There is, I think, a tacit acceptance that art belongs to the pleasure side of the balance. I suggest that art must, if it is to have any real value, transcend the paradox and Colin Self should be bracketed with people like Rauschenberg and Warhol who have managed to use figuration as a means of achieving this transcendence.

14 · Clive Barker

b. 1940

Clive Barker's objects function within the framework of
irony that derives from Duchamp's ready mades and
which itself belongs to the broader tradition of the artist
as dandy – a notion that stretches back through Baude-
laire and Nerval to the Mannerists, and beyond them to
Hellenistic culture. In the present century, the artist/
dandy has generally expressed himself by the exclusive
means of the arrogant and ironic gesture. Barker strikes a
different note in that his objects are in themselves marked
by an extreme elegance totally removed from, for instance,
Man Ray's *The Enigma of Isidore Ducasse*, or, even, from
Jasper Johns's beer cans. In Barker's world, chromium-
plated false-teeth rest in a tumbler of water (Figure 66),
vegetables in a still life are enamelled the same uniform
black as the table surface upon which they rest, gold
paint-tubes and brushes lie in a gold paintbox. The banal
is metamorphosed into the perfect.

These pieces have the elegance of *objets d'art* and yet
are something quite different. Their perfection is not an
end in itself but acts as a foil for the artist's irony (and,
as with Duchamp, this is not a negative irony but the
irony of affirmation). The perfection of an *objet d'art* is
intrinsically prosaic since it contains no ambiguities; a

Daum vase or a Fabergé music-box functions lyrically
only as a component in a personal environment. Barker's
objects, by contrast, are lyrical in themselves – charged
by the ambiguities that exist between banality and per-
fection.

Barker's earliest objects capitalized upon the elegance of
black leather. A large expanse of leather was topped by the
word EXIT – spelt out in neon. A smaller rectangle of
leather was fastened by a chrome zip. These belonged to
the classic tradition of the surrealist object and it was
possible to detect a relationship, in terms of sensibility at
least, with the work of some recent American artists –
Jasper Johns, for instance, and Jim Dine. The transition
between these earlier pieces and Barker's later work was,
in fact, a piece dedicated to Jim Dine. This consisted of a
pair of palettes (Jim Dine had been preoccupied with the
palette, notably in a series of paintings involved with a
self-portrait theme and with symbolic portraits of the
Dadaist Francis Picabia). Barker made one palette from
leather but the other was made from chromed brass. This
piece was created in 1964/5 and from that point the metal
object – frequently finished in chrome or nickel – was to be
his most usual vehicle of expression.

The first of Barker's objects to attract public attention
was a chromed, life-sized reconstruction of Van Gogh's
chair (complete with pipe and ashtray resting on the simu-
lated wicker seat). This chair – if not, perhaps, typical of
the artist's best work – is certainly eye-catching. To see the
familiar image – which has become, by way of thousands of
cheap reproductions, virtually a votive icon for the culture-
hungry masses – translated into a gleaming solid reality

had a considerable shock value. Three versions of the chair were made, each standing on an expanse of plated metal tiles.

The chair was followed by a pair of still lifes, each of which was arranged on a full-sized metal table (Figure 67). The objects organized upon each table surface – all of them, of course, either cast in or cut from metal – included a candle-stick, a book, a postcard, vegetables and a plate, plus, once more, a pipe and ashtray. One version of this table was chromed while the other was finished in black enamel. A related work of about the same period was a plated reconstruction of a Morandi still life – a sober arrangement of bottles upon a chrome sheet with a vertical back-plate, also chromed. Along with these larger pieces came a number of smaller objects: the dentures already mentioned; an harmonica with a zippered embouchure; a chrome-plated bucket of raindrops (raindrops which consisted in fact of 12,000 ball-bearings).

The everyday nature of the subject matter in these smaller pieces emphasizes a quality which is perhaps central to Barker's work. Exactly what I mean by this I have already hinted at in talking of the ambiguities between banality and perfection. Barker is likely to take the most commonplace subject and treat it with the kind of technical elegance, bring to it the kind of detailed crafts- manship that is normally reserved for the engines of racing cars or the packaging of astronauts. The chromium-plated dentures, in their tumblers of water, have an ironic dignity which places them at one remove from the outright humorous.

Duchamp articulated his ready mades by isolating them

from their everyday environment. He talked of 'planning for a moment to come (on such a day, such a date, such a moment) ''to inscribe a ready made'' – the ready made can later be looked for (with all kinds of delays). The important thing then is just this matter of timing, this snapshot effect, like a speech delivered on no matter what occasion but *at such and such an hour*. It is a kind of rendezvous.' The ready made, we may say, was isolated from its environment by a calculated combination of choice and chance; but its isolation is only partial – it in turn articulates its former environment since by this act of *inscription* Duchamp gives us a tool to grasp that environment, every constituent of which takes on a position in a greater pattern of choice and chance. Barker isolates his objects from their environment by translating them into elegant pieces of craftsmanship. While they clearly have a generic relationship with the ready made, the means by which Barker achieves his irony is perhaps more reminiscent of those employed by Duchamp in his creation of *The Large Glass*. Not that aspect of *The Large Glass* which involved Duchamp in playing elaborate games with post-Symbolist literary notions; but the obsession with precision, with details of execution.

Duchamp has, of course, been obsessed with the idea of 'art' and has often played ironically with notions dear to 'the artist' – for example, the catalogue of plastic devices incorporated into his final oil painting *Tu M'*, or the joking use of his own signature in *Chèque Tzanck*. In 1967 Barker created two versions of an object which consisted of a paintbox and palette. One version was finished in chrome, the other in gold; both rested on black vitrolite

bases. Each box contains tubes of paint, bottles for oil and turps, mixing vessels, brushes and a palette knife. All these objects were made in metal, plated and polished. In the gold box, the paint-tubes are tumescent with imaginary pigment. In the case of the chrome box, the tubes are twisted and half spent. These paintboxes have a very lyrical feel about them, reminiscent of certain Joseph Cornell boxes.

Another pair of pieces which Barker conceived at about the same time reverts to his concern with the everyday. From a chromed back-plate projects a plated faucet, and on a plated base stands a nickelled bucket half filled with ball-bearings (similar to that employed in *Bucket of Raindrops*). In one version the tap appears to be full on and the column of water is represented by a fluted metal rod. In the other version we are asked to imagine that the tap is turned off but still dripping; droplets of chrome seem to slip down a thread of nylon. In both cases 'splashes' of chrome emerge from the ball-bearings on curving wires (Figure 68). A related project consists of a shower unit – complete with splash-board and base made from chrome-plated tiles.

Smaller pieces include an edition of hand-grenades – cast in steel and chromium-plated; also a plated newspaper (Figure 69).

All these, when considered together, begin to add up to a ghost world existing parallel with the real world yet removed from it – though 'ghost world' is not perhaps the most accurate description since these pieces are palpably solid. It would perhaps be more accurate to describe it as a super-real world. What we are confronted with in the

chrome or gold objects is something akin to an ironic equivalent for the Midas touch. From another point of view, Barker's objects approximate to Platonic ideas – their tangibility does not destroy the sensation that they might be abstractions upon which the real world of objects is striving to model itself; but, here again, this functions within an ironic framework. One notable feature is that the objects are frozen – the column of water pouring from the faucet is solid. Yet the objects are accurate facsimiles of reality and so a curious paradox is expressed. They occupy space but seem to defy time.

15 · Jann Haworth
b. 1942

Nicholas Munro
b. 1937

Jann Haworth and Nicholas Munro are both figurative
sculptors, but figurative in a way totally removed from the
Graeco-Roman tradition. They have arrived at their
present positions quite independently of each other (or of
anyone else). It is tempting to describe their work as being
eccentric. In the past most of the greatest English practi-
tioners of the visual arts, from Blake and Turner down-
wards – and this extends to adoptive Englishmen like
Whistler – have had this appearance of eccentricity, some-
times leavened with dandyism. The Renaissance/main-
stream complex in recent English sculpture has probably
emerged in reaction to this – a natural yen for cultural re-
spectability and a useful creative drive. Happily, there is a
streak of dandyism here too, which leaves room for hope.
The dandy and the eccentric (Hamlet and Falstaff) are
cultural phenomena that have reached a kind of peak in
England. Neither of the sculptors that I am about to
discuss falls inherently into either of these categories but
both have an intimate knowledge of the idioms involved.

Jann Haworth is a native of California now permanently
resident in London (she is married to the painter Peter

Blake). The world of humanoid dolls, quilted comic-strips and gigantic jewellery that she has brought into existence reflects her American background without introducing either overtly critical or nostalgic overtones (Figure 70). She appears, rather, to be marvelling at the objectivity that she has acquired through her change of situation. She records with humour things with which she may at one time have been emotionally involved, but which she is now able to enjoy in a new and more detached way. This fixing of the past is, however, only her starting point; her dolls and objects are more than simple mementoes. They are symptomatic of a new relationship between man and his environment; even ten years ago they would have been conceived in a totally different way, but to understand just why – it will be necessary to go back a little further than that.

While perspective remained the ruling principle in art, figures and objects existed in a diminishing space at the centre of which was Man. This contrasts with the inverse perspective used to portray the God-centred universe of the Byzantines, and with the lack of formal perspective in Chinese art: as the Chinese artist thought of Man as on merely equal terms with the rest of Nature, he saw no point in establishing for him a privileged viewpoint.

Along with the Western artist's assumption of the centrality of Man came a concern with the mastery of common-sense realism. The mind was conceived as an instrument powerful enough to hold the world together – to impose an order upon it. The break-down of this faith can be traced through the Romantic revolution, Impressionism and Post-Impressionism, Cubism and Dadaism. It is only during the

past decade that the common-sense visual experience has become once more a respectable object of the artist's professional attentions.

Returning from the twin impasses of total abstraction and the totally irrational, artists found the world changed – largely as a result of their own activities. That science, engineering, telecommunications have radically altered our environment goes without saying. Facts are grasped in new ways. New creeds – from Freud to cybernetics – have replaced the old.

Jann Haworth's dolls reflect these changes; they belong to the sixties. This applies even, for instance, to her model of Mae West which – for all its thirtyish overtones – depends on a total acceptance of cinema illusion which would have been impossible for an immediate contemporary of the film-star. We look into the bulb-lined mirror of the star's dressing table and, beyond the glass, the star smiles back at us. The mirror is in fact a sheet of clear glass, and the 'reflection' a three-dimensional figure behind the glass. We are accustomed to seeing Mae West flattened to two dimensions and it is by a manipulation of this habit of vision that the artist has been able to complete the illusion. Or, rather, not quite complete it; it is we, with our knowledge and habitual acceptance of illusion – especially cinema illusion – who are required to do that. Our active participation at this stage of the creative process lends the model a particular vitality.

Jann Haworth sometimes plays tricks with scale which also seem to owe a great deal to the sensibility of cinema. It is, of course, nothing new for an artist to create people or things larger than life, but in the past the chances were

that he was doing so to achieve an impression of Olympian grandeur. When Jann Haworth made her huge *Charm Bracelet* of quilted orange satin her motives were quite different. She wanted, simply, to find a scale which would allow her to explore fully the details that especially interested her. Iron or bronze would have rendered the project lugubriously absurd. Quilting – combining lightness with an appearance of solidity – was the perfect solution, giving her scale without pomposity. This bracelet might be a prop for some million-dollar production of Gargantua and Pantagruel; the discrepancy between size and weight, between the texture of fact and the texture of illusion has just the flavour of the cinema epic.

Mr Dream – a life-sized surfer rippling with quilted muscles and covered with a suntan stockinette – offers in some ways a more complicated case. The image of surfing has been distorted, simplified and amplified by mass media and this is reflected in what I can only describe as the density of the figure. If we are to judge surfers simply from the promotional agitation that surrounds them then it becomes difficult to think of them as more than beautiful robots – walking testbeds of behaviourist abdication who can be adequately explained in terms of antigravity mechanisms, glandular secretions and motor impulses. Yet a weird lyricism seems to surround them. All this is captured in *Mr Dream*; the outlandish combination of commercial image and its feedback to living fact. We are reminded of those film actors with the heads and bodies of Greek Gods whose intelligence does not seem sufficient to sustain so much physical perfection; and yet they are not quite dead.

But Jann Haworth's attitude to her surfer is quite friendly; there is no element of censure present – none of the professional exile's self-conscious rejection of trans-atlantic patterns and things American. Instead she is content to allow *Mr Dream* the pleasures of his transis-torized arcadia and takes pleasure in the simple fact of his existence.

One question, I think, is likely to occur to anyone look-ing at Jann Haworth's work – a question that is purely academic. Is it a sculpture? And if not, what is it?

A piece of sculpture worthy of the name not only dis-places space but articulates it, bringing it to life. By contrast, a waxwork dummy seems to soak up whatever vitality it finds in its surroundings, enervating an entire room. Far from bringing a figure to life, the concern with detail that is found in the waxwork model – the rouged cheeks, the false eyelashes – seems to heighten the sense of theatrical deadness, numbing an illusion of reality. A piece of sculpture like Brancusi's *Mademoiselle Pogany* reduces the human head to a simplified sequence of planes yet the sculptor has been able to endow it with more vitality than can be mustered by the assembled popula-tion of Madame Tussaud's.

What makes Jann Haworth's work so interesting is that she seems to have more of the wax-craftsman's concern with detail than the sculptor's with spatial articulation – yet her dolls are not dead. Far from it; each has just the degree of life required to give it a convincing existence. Her Mae West exudes the vicarious sensual vitality of the cinema idol. Her surfer seems governed by the automatic hedonism and vanity of the beach robot. What – if not

the sculptor's spatial artistry – makes them work? Not
that this artistry is entirely absent; her work has a sense
of construction and an eye for essentials that distinguishes
it clearly from the waxworks article. The padded stockin-
ette she uses tends to fall into natural positions; it has a
give entirely lacking from a medium like wax and so her
figures are never frozen into hieratic stiffness.

Beyond this she seems to possess a quality very rare in
the visual arts – something that is more commonly found
in novelists than in sculptors or painters. A writer like
Dickens seems to have carved his books from the medium
of life itself, rather than to have constructed them from
words and syntax. We are not aware in his novels of any
tension between style and character, between form and
subject (tensions such as Flaubert, for example, chose to
exploit).

Of course, even this impression of life itself being the
medium is an illusion. What happens is that the artist
employs idioms so close to everyday habit as to be in-
distinguishable from it. Each idiom is, in time, absorbed
by the people exposed to it – becomes only another tic –
and a Dickens (or a Jann Haworth) latches on to them just
before their final extinction as independent existences.

It takes incredible conviction to endow a personage
with life without putting up the transparent but inpene-
trable screen of cultural linguistics. The novelist is able to
build up our belief in a character over a period of time and
through events occurring in sequence; moreover he is not
obliged to confront us with the physical article. That Jann
Haworth is able to succeed without these advantages is a
remarkable achievement.

There are certain superficial similarities between the work
of Jann Haworth and the work of Nicholas Munro. Like
her he makes both figures and objects. Like hers, his
subjects are treated with humour and extreme sympathy.
They have more contact with the conventional world of
sculpture, being moulded in plastic – and therefore solid –
and often relying upon traditional treatment of mass and
plane to achieve their effects. The finished piece is, how-
ever, painted – generally with hard, bright gloss paints –
which removes it comfortably from the world of statuary.

Munro's idiom does not reflect the changes of the modern
world so directly as does Jann Haworth's. He is doubtless
fully aware of these changes – certainly his work takes
account of them – but, like her, he is concerned with a very
personal sphere of experience and his differs as greatly from
hers as does the English countryside from Los Angeles (he
was brought up amongst the Berkshire and Wiltshire
downs and since completing his studies, several years ago,
has returned to live there). This gives his work a very
special flavour. McLuhanland may extend as far as Great
Shefford but no one's going to be fool enough to admit it.

In Munro's sculpture the worlds of childhood and
adolescence, or rather the icons of those worlds – images
from storybooks and television – are given a new reality.
Filtered through the sophisticated screens of modern
figuration these icons are invested with a fresh set of values
which makes them accessible to the adult mind. More than
that, they are invested with qualities which give them a
function in the adult world – a function complementary to
that which they had in their original and more innocent
setting.

In the fields near Munro's house a flotilla of yachts or a
herd of life-sized red deer are liable to appear with the
silent inevitability of events in a fairy story. The yachts
have something of the appearance of boats in a child's
drawing but on close examination it will be found that the
simplifications are of a very sophisticated order – echoing
the ambiguities of abstraction/figuration which run through
the visual art of the last decade. The deer, on the other
hand, are naturalistically represented; manifestations
which have all the authority of common-sense reality – an
authority which is magically enhanced by their immobi-
lity.

It is clear at once that these are part of 'a world' – they
have an important function in their creator's mental
landscape which we are invited to share. As I have sug-
gested this function is comparable to that which characters
from a story book can come to play in a child's mind; but
the artist's plastic skill has given them a new reality which
translates them into the adult world.

Why should an artist choose to devote his time to this?
Should he perhaps be concerned with more serious mat-
ters? Is he suffering from some kind of hang-up on lost
innocence? If we pursue this tack we might as well resign
ourselves to the old irrelevant Freudian sleeper that Art
is compensation. Someone with the plastic intelligence that
Munro displays cannot be so easily dismissed. The imagery
of childhood and adolescence is a highly charged area, and
one which the artist, freed from pseudo-Renaissance
snobbery, can be expected to explore. We must in any case
be careful to distinguish between Munro's sophisticated
investigation of the imagery of innocence and its practical

role and the *faux naïf*'s attempt to reconstruct that innocence.

We must be careful too, not to underestimate the range which Munro's idiom allows him. Apart from the overt childhood imagery – snowmen, ghosts, a conjurer, a space ship and bug-eyed monsters – there are pieces which, seen in isolation, could be interpreted in quite a different way. There are, for example, life-sized suitcases, telephones and electric fires which might seem to relate to the work of someone like Oldenburg. In the context of Munro's work seen as a whole, however, these pieces take on an unexpected lyricism with overtones of holidays and winter evenings. He has also created ballroom dancers (Figure 71) and figures of young men in executive-type suits which might be read as straight satire, but once again their situation in the totality of Munro's output has given them a different idiom and more lyrical aspect. He treats them with the irony that an adolescent adopts towards the world of grown-up fantasy which he finds himself pushed towards but is unable to accept as more than a source of amusement. This curious transitional period between the illusions of childhood and the illusions of the adult world (or, one might say, between the realities of childhood and the realities of the adult world) is one that has hardly been explored. The trim figure of a sailor (more closely related to Noel Coward's Matelot than to the seamen of Kenneth Anger's *Fireworks*) loses some of his innocence when placed next to the brassy figure of a Spanish tart. But this young lady too is an authentic inhabitant of that transitional world.

Another aspect of Munro's work derives more directly

from the traditions of modern sculpture – without losing contact with his other pieces. There are Arp-like forms painted to resemble fabric, covered with tiny sheep so that they become hillsides, or transformed into clouds which support a suitcase labelled 'Par Avion'. Finally, however, it is the figures which are most immediately striking. It is in these that Munro most effectively turns his irony on the world of the dandy and the eccentrically romantic. He has made a Hamlet and – if he has not yet turned his attentions to Falstaff – he balanced this with the twisted body of Quasimodo.

When emphasis is so often placed on the steamroller of 'International Style' it is refreshing to find artists who have the strength to make art of their personal worlds and the courage to maintain the integrity of these worlds. Both Jann Haworth and Nicholas Munro fall into this category. Yet – as I hope I have shown – neither are eccentrics, hermetically sealed off from the cultural mainstream. Their contribution to the art scene can only be a healthy one.

PART TWO

16 · Communicators 1

Many of the art world's pseudo-problems arise out of a failure to distinguish between the functions of aesthetics (by which I mean, in this context, the nexus of energies posed in the art object) and the technology of communication. This is not to say that communication does not enter into any consideration of aesthetics, or that aesthetics are not relevant to communications systems; but even though the two mechanisms interact they differ radically. To give a simple example, an advertising campaign may display a masterly grasp of the technology of communication but lack all aesthetic impact. Conversely, an item of minimal art may have no traffic with the technology of communication yet have a great aesthetic impact (if only as a negation of traditional aesthetic concepts). The computer term 'software' is useful – describing the means of communication with the machine as opposed to the physical assembly. Communication with the machine is most usually achieved by means of a coded message which the computer translates into its own binary language. In this setting, communication is concerned with information, with facts; and this is often the case in other contexts.

Where the fine arts are concerned, communication is usually of a fairly complex nature. Information may be

coded in several different ways within the confines of a single work. A Renaissance painting might have part of its message coded in the form of allegory. At the same time it will convey information about the physical world – or about a possible environment built up from known fragments of the real world. The whole technique of illusion built up during the Renaissance – the evolving mastery of perspective, foreshortening, chiaroscuro – is now taken for granted but is in fact a highly sophisticated code capitalizing upon the limitation of our perceptive faculties. But none of this is more than incidental to the aesthetic impact of a Masaccio or a Mantegna. When we are confronted with a code still in the process of evolution then we are much more likely to confuse the issue of communication with that of aesthetics since the historical importance of the code tends to impose itself upon all aspects of the work under consideration. Thus the awkward foreshortening employed by Uccello to portray a fallen horseman may assume, in the art historian's mind, a totally misleading significance. Attempts are made to slot what are technical innovations into aesthetic evaluations (when they are more properly comparable to the introduction of compiler programmes – such as FORTRAN or ALGOL – into the field of computer software).

Communication systems can, of course, be used to achieve aesthetic ends – and since many artists have been involved with the technology of communication this is frequently the case. To this extent a consideration of perspective *is* relevant to Renaissance aesthetics – but it is essential to distinguish between an evolving technology of communication which the artist employs and the closed system of

energies which is his resolution of the visual programme
and which is the proper subject of aesthetics. It is when
there is a failure to distinguish between means and ends
that problems arise.

If we turn to the situations which have developed in
London and New York, over the past decade, we discover
an interesting contrast in attitudes towards the technology
of communication. I have written in an earlier chapter of
the differences between American and English Pop Art:

An artist like Oldenburg has been involved primarily with an
environment. A painter like Richard Hamilton has been con-
cerned with a media landscape. Oldenburg is engaged in a
physical situation; Hamilton is dealing with a sensibility
bombardment, the material source of which remains at several
removes from him. The psychological perspectives differ
radically. The non-American coming to terms with popular
culture must adopt something equivalent to the inverse
perspective which the Byzantines used to portray a God-
centred Universe. English Pop Art was more fruitful than its
continental equivalent because it was able to accept this action
and the idea of a media landscape. The Beatles, for that matter,
display a similar detachment – not copying American models
but re-creating from the transmitted sensibility a wholly
original language. Continental Pop artists generally attempted
to deal with their own environment using the syntax of
American art as a crutch, an approach which led inevitably to
provincialism.

From the London artist's preoccupation with the media
landscape we may infer a greater concern with the tech-
nology of communication for its own sake. Clearly artists
such as Richard Hamilton, Paolozzi (in his prints and

books), Dick Smith (particularly in his work of 1961/4) –
to which list we might add several younger contempo-
raries – have been very greatly concerned with breaking
the communication codes employed by the ad-mass world
(that is, breaking codes which have mostly developed
spontaneously, in technologically biased environments,
as attempts to satisfy unspecified and often unspecifiable
emotional needs). Hamilton's careful stylistic analysis,
Smith's involvement with the sensibility of contemporary
visual phenomena, both help us to grasp the dynamics
of mass media. Paolozzi's aleatory presentation of mass
media raw material (as in *Moonstrips Empire News*) is an
attempt to exploit new communication systems more
directly; but however the communication phenomenon is
explored or used, it is as a result of this preoccupation that
any British contribution to recent cultural evolution has
been made.

Recent American art has a very different character.
Even Warhol in his movies has been more concerned with
direct phenomenological impact (he wouldn't call it that;
the point is that he wouldn't call it anything) than with
any deliberate manipulation of the technology of com-
munication. A new technology of communication may
arise out of his experiments – but that is something quite
different. British artists influence systems of communica-
tion by a process of analysing existing systems which are
then translated into a fine art context – thus setting up
the potential for a pattern of feedback and cross fertiliza-
tion. Warhol, on the other hand, calls a new technology of
communication into existence by creating (or at least
recording) the need for such a technology (which is inci-

dental to the main impact of his work). If we turn to an
artist like Robert Morris, to his preoccupation with
Gestalt, then we are confronted with the essence of recent
American art.

It might be argued that the mini-skirt – in the engineer-
ing of which Britain played the leading role – is a classic
example of the *Gestalt* object. To me, however, it seems a
particularly neat and successful piece of communications
technology. The artful combination of occlusion and reve-
lation it exploits translates the female presence into a
delightful sequence of coded messages – information which,
while sometimes fictional, always contains the promise of
physical resolution. Where this physical resolution is
attained the technology of communication is abandoned
in favour of a *Gestalt* union.

The question arises, at what point does the technology of
communication give way to *Gestalt* considerations? The
noun *Gestalt* is defined as 'form, structure, pattern: an
organized whole (e.g. a living organism, a picture, a melody,
the solar system) in which each part affects every other, the
whole being more than the sum of its parts.' *Gestalt*, in
aesthetic terms, may be defined as the point at which all
the dynamics within, say, a painting are posed in such a
way as to enable the painting to take on an existence
independent of the world at large – to become a self-
contained entity. Communication takes place between two
or more self-contained *Gestalt* entities. Of course, within
the context of many recent intellectual systems – for
example, linguistic philosophy and behavioural psycho-
logy, as well as *Gestalt* psychology – it can be argued that
the division of physical phenomena into distinct *Gestalt*

entities is misleading since all function as part of a much
larger *Gestalt* extending, in theory, to the limits of human
consciousness; and it is with this overall *Gestalt* that many
American artists are concerned (Rauschenberg, for in-
stance, when he talks of bridging the gap between art and
reality). While I do not disagree with the general tenor of
this outlook, I think it can be quite valid and useful to
break down this overall pattern into separate entities –
bracketing constituent *Gestalts* such as a painting or a
human being. Communication is the means employed by
these constituent *Gestalts* to interact with each other in
such a way as to constitute the greater *Gestalt* (individual
constituent *Gestalts* may be further broken down into
their own constituents, each with its own systems of
communication).

American artists, then, have favoured either the brac-
keted *Gestalt* image or else a direct exploitation of the
broader *Gestalt* phenomenon (environmental situations,
etc. – as in the Happenings). English artists have been
more concerned with the technology of communication for
its own sake. The work of artists like Hamilton and
Paolozzi is often open-ended. The interest resides in the
wide implications which their *schema* presents rather than
in any *Gestalt* or formal resolution. An interesting point is
that other English artists – notably Dick Smith, Gerald
Laing and Peter Phillips – who have been involved with
the technology of communication but who have spent
long periods of time working in New York, *have* been con-
cerned with finding a *Gestalt* resolution. Smith and Laing
have achieved this resolution by abandoning some of their
early interests and developing the non-figurative aspects

of their work. Phillips's solution has been rather different and holds interesting implications for possible future developments.

Since his earliest exhibited works (1961), Phillips has remained faithful to a brand of figuration which is specifically concerned with ad-mass communication technology. But when he uses automobile advertising imagery, for example, he does not produce an open-ended stylistic analysis as did Richard Hamilton in *Hommage à Chrysler Corp*. Phillips will integrate this automobile imagery with other elements – scientific diagrams, maybe, or a pin-up – to create a composition which is totally self-contained. Superficially there might seem to be a resemblance between Phillips's paintings and those of James Rosenquist who employs a similar range of imagery and also achieves a similarly self-contained, organic image. Phillips's canvases and those of the American are, however, fundamentally different. Rosenquist uses ad-mass imagery with the same deliberate anonymity that a non-figurative artist might use colour fields. Phillips, by contrast, is analytically concerned with the communication technology from which he is borrowing.

In the computer world the term 'object program' is used to describe a complete programme assembled or compiled in machine language. The programme will have been conceived in terms of communication but when completed it becomes a self-contained organic entity. We are presented here with an interesting conjunction of the technology of communication with notions of *Gestalt*. Self-contained communication patterns can be bracketed in the same way as can extended matter – can be treated as constituent

Gestalt entities. Phillips's paintings can be considered as 'object programs'; their substance is coded ad-mass information but it is organized in such a way as to form a statement which is complete within its own terms. These paintings are, then, satisfactory on two separate counts. This is doubtless true of much traditional figurative painting but seldom, if ever, has an artist achieved this result using the technology of communication for its own sake (always, in the past, *something* was being communicated).

17 · Communicators 2

It is possible that this whole business of bracketed com-
munication patterns can best be illustrated by turning to
another medium – the cinema for example. It has often
been suggested that a film does not depend for its success
on the sustaining of a plot line – that is to say, upon
communicating a story. Clearly, in a Hollywood movie,
star quality, certain characteristic style patterns evolved
by a director, a production team, or a studio – plus sheer
technical excellence – contribute more than the logical
exposition of a story. In other words, the technology of
communication is apt to become more important than
what is communicated. Where there is a strong story line
it is likely to fit into a well established formula (as with
the Western). This again puts an emphasis on presentation
techniques rather than on what is presented, which may be
satisfactory but can be taken for granted.

This emphasis goes back to the earliest mature phase of
the cinema. The heavy moralistic story line of a Stroheim
movie does little to interfere with the enjoyment of a
present day audience. For instance, in *Foolish Wives* what
we are aware of is a sequence of behaviour patterns pre-
sented with great technical virtuosity. What moves us is a
progression of visual experiences: Stroheim firing a pistol

out into the calm Mediterranean then climbing a long
flight of steps to breakfast off caviar on a sunlit terrace
with two glamorously depraved women; Stroheim, in the
white summer tunic of an officer of the Imperial Russian
Army, twitching and leering at the ingenuous American
lady who is the object of his dubious attentions (his facial
tics alone are a marvellous exercise in the basic technology
of communication). This visual presentation of behaviour
patterns stands on its own; there is no need to look for
anything behind it. What matters – what gives the film its
impact – is the way these visual patterns are organized.

In the thirties – despite the introduction of sound – the
orchestration of visual presentation techniques reached
new heights of easy virtuosity. A Busby Barclay musical
should need no comment from this point of view but if you
turn to comedy you will find many less immediately
obvious instances of how this method of organizing film
material was taken for granted. W. C. Fields's best movies
are free-form vehicles which simply capitalize upon his
superb mastery of old carny and vaudeville routines. As
with Stroheim, Fields's mannerisms form a superbly
flexible vocabulary of basic communication technology.
Add to this his highly stylized verbal delivery and the
extraordinary balance which he achieved between lush
ineptitude and the sheer physical control of a circus
performer – the director could hardly go wrong (though
some had a fair shot). The director could simply string
together his own conventional vocabulary of presentation
techniques confident that Fields's personality – the tech-
nology of communication made flesh – would hold the
whole thing together.

Hundreds of other examples could be cited from the Hollywood movie. I have simply chosen examples which have stayed near the surface of my own mind. The point is that it was as an organized sequence of presentation techniques that these films first impressed me and it is as just such a sequence that I remember them. Certainly both Stroheim and Fields are fascinating as characters in their own right but it is the way that these characters are presented which remains vital.

An interesting fact is that the experimental cinema has not, as a general rule, capitalized upon the ease with which the cinema lends itself to the orchestration of presentation techniques for their own sake. The reasons for this may be essentially economic. The presentation techniques evolved by Hollywood have generally depended upon the expenditure of large sums of money – money spent on equipment, on sets, on stars, on extras. A 'B' movie produced by a major company is likely to cost at least one hundred times as much as the most ambitious experimental film. Certainly the early experimental cinema made great play with trick angles and the like but the amateurishness of this kind of thing, as carried out with a hand-held 16 mm. camera, disqualifies it from description as presentation technique. It seems, rather, an ingenuous failure – sidestepping the whole business of presentation and communication.

The more successful experimental films have mostly derived their impact from providing a series of existential confrontations. This is true of, for example, the Bunuel/Dali classic *Un Chien Andalou* where single images – such as the eyeball cut open by a razor – are what we recall. These discrete items are skilfully organized according to

the canons of surrealism but exist for their own sake. In this nominally irrational sequence of events and images the cinema as a facsimile of reality is the key factor, in a way that it could never have become within the context of the Hollywood movie. Much the same as I have said of *Un Chien Andalou* can also be said of the post-war American underground. A film like Anger's *Scorpio Rising* provides a direct confrontation with the fetishism of motor-cycle machinery and leather gear. This fetishism is in itself a presentation technique but Anger does not exploit this aspect of it – that is to say he does not look for a cinematic equivalent for this sub-cultural technology of communication. He is content to record it as a sequence of *Gestalt* images.

If we go back to the beginning of the experimental cinema we do find one film which did make extensive and intelligent use of presentation techniques: *Entr'acte*. This was very adequately financed (by Francis Picabia who also scripted the film). It had the advantage of having a professional, René Clair, to control the technical aspects of its making (Clair had already absorbed the lessons of Hollywood as they stood at that time). It had stars – within the terms of its own cultural values – in the persons of Duchamp, Man Ray, Eric Satie and Picabia himself. Clair – his task greatly facilitated, we may suppose, by Picabia's script – took the presentation techniques of Hollywood silent comedy and used them for their own sakes.

In certain European art films (as opposed to experimental or underground movies) a kind of compromise between the exploitation of the existential impact of the

image and the stylized orchestration of presentation techniques has been achieved. This doubtless arises from the combination of self-consciously *avant-garde* background (not an infrequent factor in European film-making but by no means a commonplace in Hollywood) and proper commercial backing plus an awareness of the entire history of the cinema. Antonioni and Godard have both, in different ways, achieved a synthesis of this kind. It remains a rarity, however, for 'serious' films to match the sheer skill in presentation of the classic Hollywood movie. This skill is for me and, more relevantly, for several important British painters, the great achievement of the cinema as a medium.

Interestingly, the strong awareness of orchestrated presentation techniques, whether conscious or instinctive, in this country is not confined to the fine artist. The Beatles, when they produced their first self-conceived film, *The Magical Mystery Tour*, offered something which made by anybody else would have been an underground movie. They offered it to a huge audience which was, perhaps predictably, taken aback. Less forgivable was the reaction of the critics who might have been expected to help the unsuspecting audience over this quite formidable hurdle. Most of the criticism was inept and petulant. What strikes me as extraordinary is that the critics felt themselves able to make very severe judgements of *The Magical Mystery Tour* on the strength of a black and white screening of the film which was, after all, conceived and shot in colour. The B.B.C. is, perhaps, to blame here. Obviously and understandably they wanted to catch the mass Christmas audience with a bang; but from any other point of view

would it not have been more satisfactory if they had screened it in colour a day or two before the black and white showing rather than a couple of weeks later? And did any of the critics risk losing face by re-reviewing what was at the time a major talking point when it was shown in colour? I may be mistaken, but I think not.

The fact is that colour makes a quite extraordinary difference to this film – just because it is a stylized exploitation of presentation techniques. A passage which, seen in black and white, may seem just an arbitrary sequence of images becomes, in colour, an organized visual pattern. The song sequences in particular in these stylized presentation techniques are carried to an extreme, and are very successful; they have the same quality of sophisticated synthesis, blending the banal and the unexpected, which we have learned to expect from the Beatles' records. In colour the whole thing was very easy to watch. And, in contrast to the underground movies which it in other ways resembles, *The Magical Mystery Tour* has the dimension of fantasy which Hollywood has always achieved through the skilful manipulation of presentation techniques. Yet, at the same time, the Beatles produced a film which has much of the same experimental excitement that is to be found in the underground cinema.

All of which is relevant to the situation of British art today. Artists such as Hamilton, Paolozzi, Smith, Tilson, Phillips, Jones have for some time used presentation techniques borrowed from the mass media – have used them in a very free and imaginative way. Now people operating within the ad-mass framework – people like the Beatles – are attempting to use these same presentation

techniques (by right their own) with something of the same freedom. It is only a matter of time before the general public accepts this freedom and this will offer a wonderful opportunity for a new liaison between the fine arts and ad-mass culture. My point is that the artist can and should play a very important role in this developing situation – and can do this by *not* getting totally involved in the ad-mass world. The artist is almost the only person who is near enough to this new situation to be in tune with its sensibility; yet he retains an independence which allows him to deal with the situation objectively. The artist is free of the immense pressures which even the Beatles, despite their extraordinary status, are subject to. This fact defines the new role which is open to the artist: that of balance mechanism in the new mass culture.

18 · On the Absence of an 'Avant-garde'

Now that London has made a claim, acceptable in some quarters, to being an art capital, it is perhaps natural to look around for signs of an *avant-garde*. The concept of *avant-garde* art is, of course, looked upon with great suspicion by many people – including a large number of creative artists; but it surely cannot be denied that in the two great art centres of the twentieth century, Paris and New York, the *avant-garde* played a vital role. The term has unfortunately been used rather casually and I should make it clear that I am not talking about the big break-throughs like Cubism or Abstract Expressionism. These now seem to have had the inevitability of natural pheno-mena and were more properly engineered by earlier *avant-garde* activity. A Braque or De Kooning has – through remaining open to forces which must eventually find an outlet – given public expression to ideas already generated by earlier experimenters (I do not wish for a moment to detract from innovations on the plastic or technical level, but I am talking of these break-throughs in spiritual and intellectual terms). It is these experimenters who are the authentic *avant-garde* men with an enormous thirst for the future and whose role was absolutely vital to the cultural

ealth of Montparnasse and Manhattan. I think of Picabia
riting:

> Moi, je suis du siècle à venir
> du siècle que je ne verrai pas
> j'ai l'espoir
> que ma naissance sera demain . . .

The physical manifestation is nothing without the
spiritual energy behind it, which makes it especially
mportant, and the generation of spiritual energy is a
prime function of the *avant-garde*. When reviewers com-
plain about 'an academy of the *avant-garde*' they are
simply contradicting themselves – though they may prefer
to call it irony. It just won't do to bracket (for the sake of
rabble-rousing copy) the trendy and spiritually progres-
sive. The concept of the *avant-garde* has acquired a definite
connotation within the framework of art history and
reviewers who deliberately or otherwise confuse it with
market-catching shifts in style deserve to be paid in used
bus tickets.

Before the sixties London had only experienced two
pockets of *avant-garde* activity. The vorticists are still
shrugged off as a neo-futurist splinter group but this is to
seriously underestimate their potential which might well
have been assimilated into the mainstream had it not been
checked by the First World War and England's cultural
isolation from Europe. Forty years passed before the next
outburst of *avant-garde* thought in Britain for which the
focus was the I.C.A.'s Independent Group. Here Paolozzi,
Richard Hamilton, the Smithsons, Alloway, Reyner
Banham and others sowed the seeds of what was to be
called Pop Art and the culture of the sixties.

But what of the seventies?

There are of course many kinds of spiritual energy but energy generated by the *avant-garde* is always intellectual in origin. Spiritual energy may well transcend the rational workings of the mind (a point which most of the *avant garde* appreciate – spending a good deal of time decrying the limitations of intellectual activity) but the fact remains that the *avant-garde* figure is someone who has exhausted the possibilities of rational synthesis and is then forced to go beyond that. Or one might say (since the process is organic) that it is the efforts of the intellect to achieve a synthesis which generates the spiritual energy to drive him further. In any case if you take the archetypal figures of the *avant-garde* – people like Jarry, Picabia, Duchamp, Breton, Cage – you will always find that the intellectual equipment has been thoroughly exercised at some stage or another, whatever their eventual opinions of its value. Their individual achievements may well be despite their intellects but in the long run their spiritual impact is because of them.

The London art scene today is notable for a sense of visual exhilaration, but (if one excepts figures like Paolozzi and Hamilton of the Independent Group generation) there is little evidence of vigorous intellectual activity on a scale other than the purely personal. The question is, how long can the sense of visual exhilaration escape stagnation without an injection of vital intellectual and spiritual activity? Does it have some other spiritual source, perhaps? Or is there an *avant-garde* which is not yet wholly manifest (since it may of course have a new form which we have not learned to recognize)? There remains the echoes of

earlier *avant-garde* explosions – the concrete poems, the odd flurry of auto-destruction – but this is something quite different.

It goes without saying that the London art scene differs radically from the classic picture of the art capital as exemplified by Paris. It also differs considerably from the New York pattern. Although London is physically a nineteenth-century city (with twentieth-century problems) it was the first to develop into a major art centre after the complete (if nominally grudging) acceptance of the ad-mass world by virtually the whole spectrum of society. In New York, by contrast, a solid art scene existed well before the advent of Pop Art and its offshoots and this has necessarily led the artist to a different and in some ways more traditional involvement. I doubt if many New York artists feel that they might equally well have become pop singers (though the Exploding Plastic Inevitable may have changed that). In London, fall-out from the art world into show biz is a firmly established trend. It would be impossible, I think, for an Andy Warhol to emerge in London because he would be absorbed too readily; he may claim to be a mass communicator but the masses prefer to put some distance between him and themselves by making him an artist. He is too dangerous. In London he would be assimilated before he found the opportunity to become so dangerous (I hope I'm wrong and that even now someone is evolving the tactics to break out of the envelope). Warhol re-created, from just the art side of the demarcation line, the McLuhan world of media as message. His involvement is impressive (especially to an English-man) yet it remains the involvement of an outsider – an

artist gone native in that other world. Many young English painters take this other world so much for granted (in England it is perhaps easier since the forces involved are not so great) that what for Warhol is involvement has for them become mere habit. To come to terms with one's environment is one thing; to sleepwalk through it is quite another.

Warhol keeps the gap between media and message open just so far as to generate tremendous creative tensions. The total acceptance of mass-communication phenomena by some English painters (and this is by no means limited to the general area of Pop) must according to all observed rules lead to stagnation unless an element of spiritual and intellectual conflict is introduced.

One outcome of the close and easy relationship between the arts and popular media in London is that the art scene is comparatively small. Many people who elsewhere or earlier would have gravitated to the fine arts are able to find satisfaction (or at least the promise of satisfaction) in more popular art forms. A certain dissatisfaction with the *status quo* is necessary to produce a large art scene. A result of this is that in London the galleries have been able to absorb almost all the genuine talent that is available at a very early stage in its development – as, or even before, the artist completes his studies; this does not lead to the establishment of an *avant-garde*. Or, rather, it cannot lead to the establishment of an *avant-garde* in the traditional sense (the fact that this is a contradiction in terms is at least encouraging). If a new intellectual/spiritual dynamic is to emerge in London it will have to cut across media distinctions between the fine arts and the demotic – an

extension, in fact, of the Independent Group's Fine/Pop Art continuum. The cultural mainstream in London now is a bizarre cross-section of high, low and medium brow in which painting and sculpture feature as focal areas of visual energy. This is all very well for the time being but the too easy equilibrium of this ménage creates a closed system and the entropy of any closed system increases with time – that is to say, it tends towards a state of maximum disorder. Conceived on a universal scale this might be the source of metaphysical exhilaration. On a localized scale it merely announces the directionless boredom of provincialism.

We must hope that, if the London art scene is to prosper, some kind of gap – however slight – can be opened up between the *status quo* and the possible state of things; we must hope for some kind of spiritual friction so that the London stream of the art world can function as a tributary of the universal. I look for the intellectual activities of an *avant-garde* as a sign of this.

I have said that a new intellectual/spiritual dynamic would have to cut across media distinctions and yet – while this remains true – a lead can be expected from the area of (or recently vacated by) the fine arts. Although the fine arts in Britain have been consciously accepted into a broader cultural pattern (witness their coverage on television, in colour supplements) they are still allowed a special licence in terms of manoeuvrability. This, of course, on the social level is their *raison d'être*. The artist as ad-mass figure must be allowed at least a minimum of manoeuvrability in order to function according to image; and in the post-McLuhan climate the personality aspect

extends to his work – the demarcation between mind and media becoming increasingly blurred. If painting is a language it can be seen, in a behavioural context, as a function of thought. But even a minimum of manoeuvrability should be sufficient. Constriction, if not absolute, may actually be an advantage since it can lead to the generation of maximum energy (the closer art is to life the more highly charged the gap between them will be). Thus I should hope to find an *avant-garde* emerging which is superficially close to the new ad-mass oriented cultural pattern but which, through some minor deviation of alignment, is responsible for the generation of intense intellectual/spiritual disturbance.

There remains the question of direction. Disturbance alone is not enough. The direction found should have the mark of inevitability – the intellect would simply clear the mind, allowing the free passage of forces that already exist. But these would have to be universal forces. What is ultimately the most disturbing feature of the London art scene is its self-indulgent preoccupation with its own problems, its own internal dynamics. These may be interesting enough for the time being although ultimately unimportant; what goes on outside is still more interesting. London has created the need for an *avant-garde*. Nature – abhorring a vacuum – should (hopefully) do the rest. A simple act is all that is needed. Someone must open the door to let the universe in. The consequences of this act will probably burst London at the seams – but what a way to go!

BIBLIOGRAPHY

GENERAL

Catalogue for *The New Generation*, Whitechapel Art Gallery, 1964. Texts by Bryan Robertson and David Thompson; statements by Caulfield, Hockney, Jones and Phillips.

Catalogue for *London: the New Scene*, Walker Art Center, Minneapolis, 1965. Texts by Martin Friedman and Alan Bowness. Bibliography by Jasia Reichardt.

Mario Amaya, *Pop as Art*, Studio Vista, 1965.

Lucy Lippard (ed.), *Pop Art*, Thames & Hudson, 1966. Includes long essay by Lawrence Alloway on British Pop.

Catalogue for exhibition of young British artists at the Musée des Beaux Arts, Brussels, 1967. Text by Richard Morphet.

RICHARD HAMILTON

Richard Hamilton, *The Bride Stripped Bare by Her Bachelors Even*, Percy Lund Humphries, 1960. Typographic version of Marcel Duchamp's *Green Box*, by R.H., with translation of Duchamp's text by George Heard Hamilton.

Richard Hamilton, 'Urbane Image', in *Living Arts* 2, 1963.

Richard Hamilton, *The Bride Stripped Bare by Her Bachelors Even*, *Again*, Department of Fine Art, University of Newcastle

on Tyne, 1966. A record of the construction of R.H.'s version of Duchamp's *Large Glass*.

Lawrence Alloway, article in *Image* No. 3, 1961.

Catalogue for *This is Tomorrow*, Whitechapel Art Gallery, 1956. Includes texts by Reyner Banham and Lawrence Alloway and a statement by R.H.

Catalogue for one man show at Hanover Gallery, 1964. Text by R.H.

Catalogue for one man show at Iolas Gallery, New York, 1967.

EDUARDO PAOLOZZI

Eduardo Paolozzi, *Metafisikal Translations*, Kelpra Studios, 1962.

Eduardo Paolozzi, *KEX*, William & Noma Copley Foundation, 1967.

Catalogue: *A Selection of Works from 1963–66*, Editions Alecto, London; Robert Fraser Gallery, London; Pace Gallery, New York, 1966. Text by E.P.

Catalogue for one man show at Hanover Gallery, 1967. Text by Christopher Finch.

Catalogue for retrospective exhibition of E.P.'s graphic work, University of California, Berkeley, in association with Editions Alecto, London, 1968. Texts by Peter Selz and Christopher Finch.

RICHARD SMITH

Catalogue for one man exhibition of paintings 1958–66, Whitechapel Art Gallery, 1966. Contains interview with R.S.

Catalogue for Saö Paolo Biennale, British Council, 1967. Text by Christopher Finch.

Catalogue for exhibition at Jewish Museum, New York, 1968.

JOE TILSON

Joe Tilson, 'Ziggurat', in *Art and Artists*, October 1966.

Joe Tilson, 'The Porcelain Factory Questionnaire', *Control*, 1967.

Catalogues for one man shows at Marlborough New London Gallery, 1962, 1964, 1966.

Catalogue for one man show at Marlborough Gallery, Rome, 1967. Text by Christopher Finch.

PETER BLAKE

Robert Melville, 'The Durable Expendables of Peter Blake', in *Motif* 10, 1962.

Catalogue for one man show at Robert Fraser Gallery, 1965. Text by Robert Melville.

ADRIAN BERG

Catalogue for one man show at Arthur Tooth & Sons, London, 1967. Text by A.B.

R. B. KITAJ

Catalogue for one man show at Marlborough New London Gallery, 1963. Texts by R.B.K.

Catalogue for one man show at Marlborough-Gerson Gallery, New York, 1964. Text by R.B.K.

PETER PHILLIPS

Catalogue for *Primary Structures*, exhibition at Jewish Museum, New York, 1966.

Lawrence Alloway, 'Hybrid', in *Arts Magazine*, May 1966.

G. R. Swenson, 'Hybrid', in *Art and Artists*, June 1966.

Catalogue for one man show at Galerie Bischofberger, Zurich, 1967. Text by Christopher Finch.

GERALD LAING

Gerald Laing and Reyner Banham, 'Notes toward a definition of U.S. AUTOMOBILE PAINTING as a significant branch of MOBILE MODERN HERALDRY', in *Art in America*, October 1966.

Michael Findlay, 'The Efficiency Game', in *Art and Artists*, January 1967.

ALLEN JONES

Allen Jones and Christopher Finch, 'Shoe Box', in *Art and Artists*, June 1968.

Ira Licht, article in *Studio International*, July 1967.

Catalogue for one man show at Arthur Tooth & Sons, London, 1967.

DAVID HOCKNEY

Guy Brett, 'David Hockney, a Note in Progress', *The London Magazine*, April 1963.

PATRICK CAULFIELD

Catalogue for one man show at Robert Fraser Gallery, 1968.

COLIN SELF

Colin Self, statements in *Studio International*, September 1967, December 1968.

CLIVE BARKER

Catalogue for one man show at Robert Fraser Gallery, 1968.

CATALOGUE OF ILLUSTRATIONS

1 Study for *Hommage à Chrysler Corp.* By Richard Hamilton, 1957. Pen and ink, gouache and collage, $13\frac{1}{2} \times 8\frac{1}{2}$ ins. Robert Fraser Gallery (photo: Brompton Studio).

2 *Interior II.* By Richard Hamilton, 1964. Oil, collage, cellulose, metal relief on panel, 48×64 ins. Collection, The Tate Gallery, London. Robert Fraser Gallery (photo: Brompton Studio).

3 *My Marilyn.* By Richard Hamilton, 1965. Oil, collage on hardboard, $40\frac{1}{2} \times 48$ ins. Collection, The Stuyvesant Foundation, London. Robert Fraser Gallery (photo: Brompton Studio).

4 *Trafalgar Square.* By Richard Hamilton, 1965–6. Oil on photograph on panel, 32×48 ins. Robert Fraser Gallery (photo: Brompton Studio).

5 *The Solomon R. Guggenheim.* By Richard Hamilton, 1965. Ink drawing, $20\frac{1}{2} \times 20\frac{1}{2}$ ins. Robert Fraser Gallery (photo: Brompton Studio).

6 *The Solomon R. Guggenheim.* By Richard Hamilton, 1965. Fibreglass and cellulose, $48 \times 48 \times 7\frac{3}{4}$ ins. Robert Fraser Gallery (photo: Brompton Studio).

7 *The World Divides into Facts.* By Eduardo Paolozzi, 1963. Aluminium, H – $89\frac{1}{2}$ ins. The Hanover Gallery (photo: Tudor Photos Ltd).

8 *Pisthetairos in Ipsi.* By Eduardo Paolozzi, 1965. Aluminium, $65 \times 135 \times 54\frac{1}{2}$ ins. The Hanover Gallery.

9 *Durenmal.* By Eduardo Paolozzi, 1965. Chrome-plated steel, H—60½ ins. The Hanover Gallery (photo: Brompton Studio).

10 *As is When – Artificial Sun.* By Eduardo Paolozzi, 1965. Screenprint, 38 × 25¾ ins. Editions Alecto Ltd (photo: Deste, photography).

11 From *Moonstrips Empire News.* By Eduardo Paolozzi, 1967. Screenprint, 15 × 10 ins. Editions Alecto Ltd (photo: Deste, photography).

12 Montage for *General Dynamic F U N.* By Eduardo Paolozzi, 1968. 15 × 10 ins. Editions Alecto Ltd (photo: Deste, photography).

13 From *Universal Electronic Vacuum.* By Eduardo Paolozzi, 1967. Screenprint 39 × 25 ins. Editions Alecto Ltd (photo: Deste, photography).

14 *Revlon.* By Richard Smith, 1960. Oil on canvas, 72 × 90 ins. Kasmin Ltd (photo: Brompton Studio).

15 *Fleetwood.* By Richard Smith, 1963. Oil on canvas, 99 × 99 ins. Kasmin Ltd. Private Collection, London.

16 *Surfacing.* By Richard Smith, 1963. Oil on canvas, 54 × 35 × 22 ins. Whitechapel Gallery. Private Collection, London.

17 *Red Carpet.* By Richard Smith, 1964. Acrylic on canvas, 70 × 36 × 18 ins. Richard Feigen Gallery, New York (photo: Eric Pollitzer).

18 *Gift Wrap.* By Richard Smith, 1963. Oil on canvas, 208 × 80 × 33 ins. Kasmin Ltd.

19 *Ring a Lingling.* By Richard Smith, 1966. Liquitex on canvas, 86 × 252 × 17 ins. (3 part). Richard Feigen Gallery, New York (photo: Geoffrey Clements, New York).

20 *Odeon.* By Joe Tilson, 1962. Painted wood relief, 83 × 71½ ins. Marlborough Fine Arts Ltd.

21 *A–Z, a contributive picture.* By Joe Tilson, 1963. Mixed media, 92 × 60 ins. Marlborough Fine Art Ltd.

22 *3D Geometry.* By Joe Tilson, 1965. Screenprint on vacuum formed cabulite, butyrate and mirralon, 36½ × 24¼ ins. Marlborough Fine Art Ltd.

23 *Ziggurat III.* By Joe Tilson, 1965. Acrylic on wood relief, 79½ × 104 ins. Marlborough Fine Art Ltd.

24 *Diapositive, Empire State Building.* By Joe Tilson, 1967. Screenprint on acetate film with metalized acetate film, 20 × 28 ins. Marlborough Fine Art Ltd.

25 *Everly Wall.* By Peter Blake, 1961. Collage, 36 × 24 ins. Robert Fraser Gallery (photo: Brompton Studio).

26 *Le Petit Porteur.* By Peter Blake, 1964–5. Cryla on hardboard, 30½ × 18½ ins. Robert Fraser Gallery (photo: Brompton Studio).

27 *Pin-Up Girl.* By Peter Blake, 1965. Cryla on hardboard 14 × 12 ins. Robert Fraser Gallery (photo: Brompton Studio). Collection Jo Grimond, Richmond.

28 *Five.* By Adrian Berg, 1965. Oil, 42 × 42 ins. Arthur Tooth & Sons.

29 *Snakes and Ladders.* By Adrian Berg, 1966. Tempera and acryla, 38½ × 17 ins. Arthur Tooth & Sons.

30 *Europe by Rail.* By Adrian Berg, 1966. Tempera, acryla and oil, 40 × 40 ins. Arthur Tooth & Sons (photo: A. C. Cooper Ltd).

31 *Tarot Variations.* By R. B. Kitaj, 1958. Oil on canvas, 44 × 34 ins. Marlborough Fine Art Ltd.

32 *Cracks and Reforms and Bursts in the Violet Air.* By R .B. Kitaj, 1962. Oil on canvas, with collage, 48 × 48 ins. Marlborough Fine Art Ltd.

33 *Portrait of Norman Douglas.* By R. B. Kitaj, 1963/4. Oil on canvas, 48 × 48 ins. Marlborough Fine Art Ltd.

34 *What is a Comparison?* By R. B. Kitaj, 1965. Screenprint, 31 × 22⅛ ins. Marlborough Fine Art Ltd.

35 *Mort.* By R. B. Kitaj, 1966. Screenprint, 39⅞ × 27¾ ins. Marlborough Fine Art Ltd.

36 *For Men Only starring MM and BB.* By Peter Phillips, 1961. Oil and collage, 108 × 60 ins. Collection The Calouste Gulbenkian Foundation.

37 *Custom Painting No. 4.* By Peter Phillips, 1965. Oil on canvas, 84 × 69 ins. Collection Galerie Bischofberger, Zurich.

38 *Custom Painting No. 8.* By Peter Phillips, 1965. Oil on canvas, 85 × 148 ins. Collection Galerie Bischofberger, Zurich.

39 *The Lion No. 2.* By Peter Phillips, 1968. Mixed media on paper, 72 × 102 cm. Kornblee Gallery, New York.

40 *Tarzana.* By Peter Phillips, 1968. Mixed media on paper, 72 × 102 cm. Kornblee Gallery, New York.

41 *Tiger Tiger.* By Peter Phillips, 1968. Oil and casein tempera on canvas with plexiglas, 89 × 59 ins. Galerie Bischofberger, Zurich.

42 *Number Sixty-Seven.* By Gerald Laing, 1965. Oil on canvas, 58 × 44 ins. Richard Feigen Gallery, New York (photo: Geoffrey Clements, New York). Collection Mr Richard Shore, Brookline, Mass.

43 *Deceleration 1.* By Gerald Laing, 1964. Oil on canvas, 71⅝ × 75¼ ins. Richard Feigen Gallery, New York (photo: Geoffrey Clements, New York). Collection Museum of Modern Art, Nagaoka, Japan.

44 *Orange Skydiver.* By Gerald Laing, 1964. Oil on canvas, irregular 2-piece canvas, 56 × 35 ins. Richard Feigen Gallery, New York (photo: Oliver Raker Associates, Inc.). Collection Mr Ulrich Franzen, New York.

45 *Slide.* By Gerald Laing, 1965. Baked enamel on aluminium chrome on steel, 98 × 49 ins. Richard Feigen Gallery,

New York (photo: Geoffrey Clements, New York). Collection John G. Powers, Aspen, Colorado.

46 *Purple Pin.* By Gerald Laing, 1967. Acrylic lacquer on aluminium chromium on brass slate base, $41\frac{1}{2} \times 12 \times 6$ ins. Richard Feigen Gallery, New York (photo: Geoffrey Clements, New York). Collection Mr and Mrs Henry Feiwel, New York.

47 *The Battle of Hastings.* By Allen Jones, 1961/2. Oil on canvas, 72×72 ins. Arthur Tooth & Sons (photo: A.C. Cooper Ltd).

48 *2nd Bus.* By Allen Jones, 1962. Oil on canvas, $49 \times 12 \times 12$ ins. Arthur Tooth & Sons (photo: A. C. Cooper Ltd).

49 *The Long Distance Fighter.* By Allen Jones, 1962. Oil on canvas, $60 \times 60 + 12 \times 12$ ins. Arthur Tooth & Sons, (photo: A.C. Cooper Ltd).

50 *... Dance with the Head and the Legs.* By Allen Jones, 1963. Oil on sized duck. 72×60 ins. Arthur Tooth & Sons.

51 *Green Dress.* By Allen Jones, 1964. Oil on canvas (inverted L), 50×38 ins. Arthur Tooth & Sons (photo: A.C. Cooper Ltd).

52 *You Dare.* By Allen Jones, 1967. Oil on canvas with plastic faced metal steps, 72×60 ins. Arthur Tooth & Sons (photo: A.C. Cooper Ltd).

53 *Typhoo Tea. Painting in the illusionistic style.* By David Hockney, 1960. Oil on canvas, 91×32 ins. Kasmin Ltd (photo: John Donat Photography). Private Collection.

54 *Marriage of Styles I.* By David Hockney, 1962. Oil on canvas, 72×60 ins. Kasmin Ltd (photo: Brompton Studio). Collection Tate Gallery, London.

55 *A Bigger Splash.* By David Hockney, 1967. Acrylic on canvas, 96×96 ins. (photo: Brompton Studio). Private Collection, London.

56 *A Neat Lawn.* By David Hockney, 1967. Acrylic on canvas, 96 × 96 ins. Collection Kasmin Gallery (photo: Brompton Studio).

57 *Red, White and Black Still Life.* By Patrick Caulfield, 1966. Oil on board, 36 × 60 ins. Robert Fraser Gallery (photo: Brompton Studio).

58 *View of the Bay.* By Patrick Caulfield, 1964. Oil on board, 72 × 48 ins. Robert Fraser Gallery. Collection British Council.

59 *View inside the Cave.* By Patrick Caulfield, 1966. Oil on canvas, 48 × 84 ins. Robert Fraser Gallery (photo: Brompton Studio).

60 *The Well.* By Patrick Caulfield, 1966. Oil on board, 48 × 84 ins. Robert Fraser Gallery (photo: Brompton Studio).

61 *New York Street and Woman.* By Colin Self, 1965. Coloured pencil, pencil on paper, 18 × 24 ins. Robert Frazer Gallery. Collection C. Self (photo: Brompton Studio).

62 *She's got everything she needs, she's an artist, she don't look back – Fallout Shelter 5.* By Colin Self, 1965. Pencil, coloured pencil, fluorescent paper, glitter, 20 × 16 ins. Collection C. Self (photo: Brompton Studio).

63 *Cinema Series (Coincidence no. 1).* By Colin Self, 1965. Collage, pencil and coloured inks, 15 × 22 ins. Robert Fraser Gallery (photo: Brompton Studio).

64 *Hot Dog 10.* By Colin Self, 1966. Coloured pencil (unfinished state), 15 × 22 ins. Robert Fraser Gallery (photo: Brompton Studio).

65 *Beach Girl, Nuclear Victim.* By Colin Self, 1966. Mixed media, 67½ × 27 × 12 ins. Robert Fraser Gallery (photo: Brompton Studio).

66 *Tom Bruen's Teeth.* By Clive Barker, 1966. Chrome-plated brass, 5 × 7 × 3 ins. Robert Fraser Gallery (photo: Brompton Studio).

67 *Still Life with Drawing Board.* By Clive Barker, 1966.

Chrome-plated steel, 29¾ × 35 × 27 ins. Robert Fraser Gallery (photo: Brompton Studio).

68 *Splash!* By Clive Barker, 1967. Chrome-plated steel, 34 × 14 × 15 ins. Robert Fraser Gallery (photo: Brompton Studio).

69 *Newspaper.* By Clive Barker, 1967. Chrome-plated brass, 2 × 14 × 18½ ins. Robert Fraser Gallery (photo: Brompton Studio).

70 *Lindner Dolly.* By Jann Haworth, 1967. Cloth, 64 × 36 ins. Robert Fraser Gallery (photo: Brompton Studio).

71 *Dancers.* By Nicholas Munro, 1966. Fibreglass, woman: 66 ins high. Man: 77 ins high (with base). Robert Fraser Gallery (photo: Brompton Studio).

More about Penguins and Pelicans

Penguinews, which appears every month, contains details of all the new books issued by Penguins as they are published. From time to time it is supplemented by *Penguins in Print* – a complete list of all our available titles. (There are well over three thousand of these.)

A specimen copy of *Penguinews* will be sent to you free on request, and you can become a subscriber for the price of the postage – 4s. for a year's issues (including the complete lists). Just write to Dept EP, Penguin Books Ltd, Harmondsworth, Middlesex, enclosing a cheque or postal order, and your name will be added to the mailing list.

Some other books published by Penguins are described on the following pages.

Note: *Penguinews* and *Penguins in Print* are not available in the U.S.A. or Canada

Art and Revolution
Ernst Neizvestny and the Role of the Artist in the USSR

John Berger

The development and character of Russian art, the
situation of the visual artist in the USSR today,
the meaning of revolutionary art and many other
vital topics are explored and discussed in this new
book by the author of *Success and Failure of
Picasso*.

The struggle to emancipate the visual arts in the
USSR is epitomized by the sculptor Neizvestny, a
legendary figure among the younger artists, poets,
students and intellectuals. It is virtually impossible
for a Soviet sculptor to work independently, but
despite every pressure brought to bear, Neizvestny
has resisted – as his sculptures testify – and
refused to conform.

Neizvestny is not opposing 'private' art to 'public'
art. He creates his monumental sculptures *for* the
public, *for* the crowds, and the best of his work
expresses an essential part of the experience
being lived by millions of people in the world
today – the struggle for freedom from exploitation.
Neizvestny's sculpture is a living monument to the
endurance needed for that struggle.

Not for sale in the U.S.A.

Success and Failure of Picasso

John Berger

Picasso is a phenomenon. Enigmatic, provocative,
notorious ... to some the greatest painter of our
times, to others a name synonymous with every
outrage of modern art and its inflated prices.

What is Picasso ... superman or victim, great
painter or great showman?

John Berger's critical re-assessment, specially written
for Penguins, investigates every period of Picasso's
life and work – from his early 'Blue Period',
through Cubism and the compositions that
culminated in 'Guernica', up to the present day.
From this study of the most controversial artist of
our age there emerge illuminating perspectives on
the position of art in the twentieth century and
the nature of our society, and on the historical
factors which have determined them.

Success and Failure of Picasso is a brilliant portrait
of the personality and art of a man as
ambiguous as our times.

The Medium is the Massage

Marshall McLuhan and Quentin Fiore

What is McLuhanism? Reviewing this book in
Book Week, Arthur M. Schlesinger Jr. answered:
'It is a chaotic combination of bland assertion,
astute guesswork, fake analogy, dazzling insight,
hopeless nonsense, shockmanship, showmanship,
wisecracks, and oracular mystification, all mingling
cockily and indiscriminately in an endless and
random monologue. It also, in my judgement,
contains a deeply serious argument.'

The essence of this compelling argument is that
society has always been 'shaped more by the
nature of the media by which men communicate
than by the content of the communication'. With
the aid of the typographical and design ingenuity
of Quentin Fiore, this book has been made an
inventory of effects, an exposition of McLuhan's
prophecies of the electronic age which may shatter
one's sense of what a book is for ever. This is not a
treatise but a happening, not a message but a
massage.

Also available in Penguins:

McLuhan: Hot and Cool
A Critical Symposium edited by G. E. Stearn

Not for sale in the U.S.A. or Canada

Ahead of the Game
Four versions of Avant-Garde

Calvin Tomkins

Fraud, frenzy, or simple fun?

Four 'way-out' artists of the avant-garde serve to
exemplify today's trends in painting, sculpture,
and music towards an indeterminate play of
chance and motion and the fusion of art and life.

Marcel Duchamp, whose ready-mades include
Bicycle Wheel and *Bottle Rack.*

John Cage, composer of random music and a piece
for silent piano.

Jean Tinguely, creator of 'meta-matic' sculpture and
happy machines.

Robert Rauschenberg, who shocked the world with
Bed and a stuffed goat entitled *Monogram.*

Not for sale in the U.S.A. or Canada